THIS BOOK BELONGS TO

About Me

Hello! My name is Audrey De La Cruz, a.k.a. Annotated Audrey. I am an artist, crafter, writer, nature lover and coloring book illustrator. I have a degree in Anthropology from the University of California, Los Angeles and a background working in education administration at UCLA. Born and raised in Los Angeles, California, I currently live in Tucson, Arizona. From my cozy home in the desert, I make art and write about creative projects on my blog annotatedaudrey.com. Common themes in my art include strong female characters, desert plants, flowers and tons of intricate patterns. While I typically work in pen, colored pencil, acrylic and watercolor, I enjoy experimenting with all kinds of mediums and techniques. I firmly believe that anyone can be artistic and I encourage everyone to explore and find their creative spark.

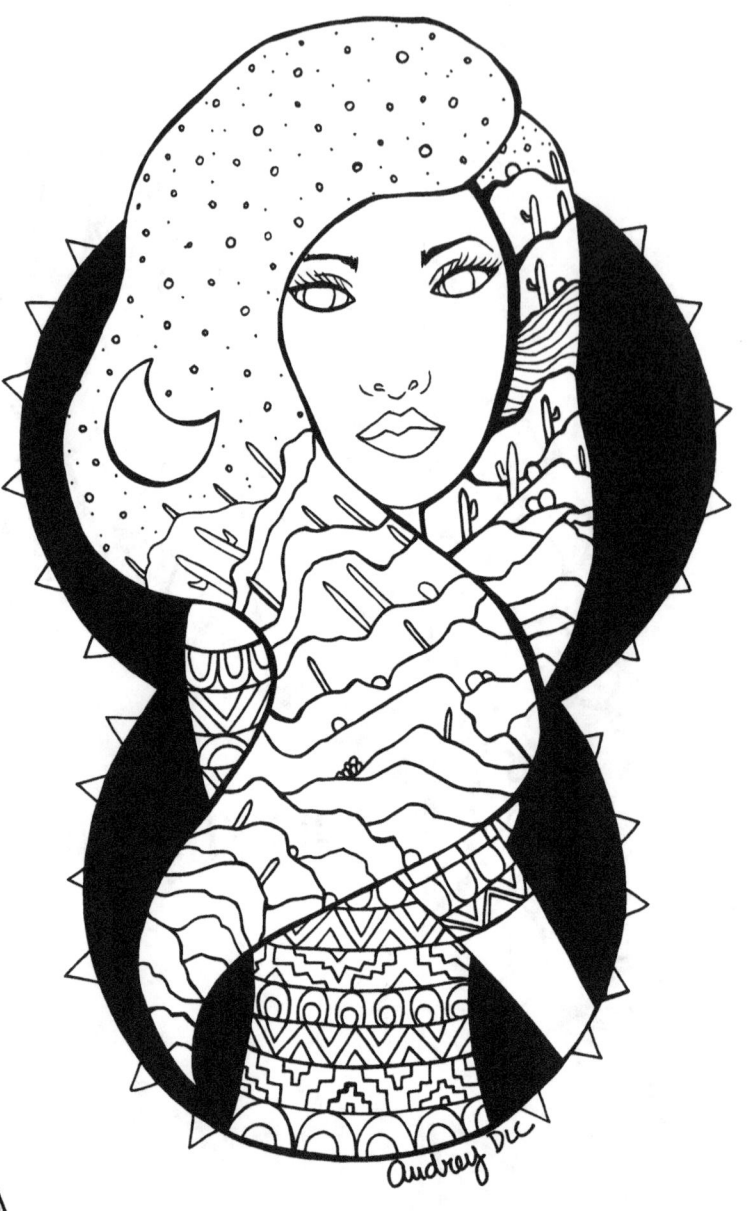

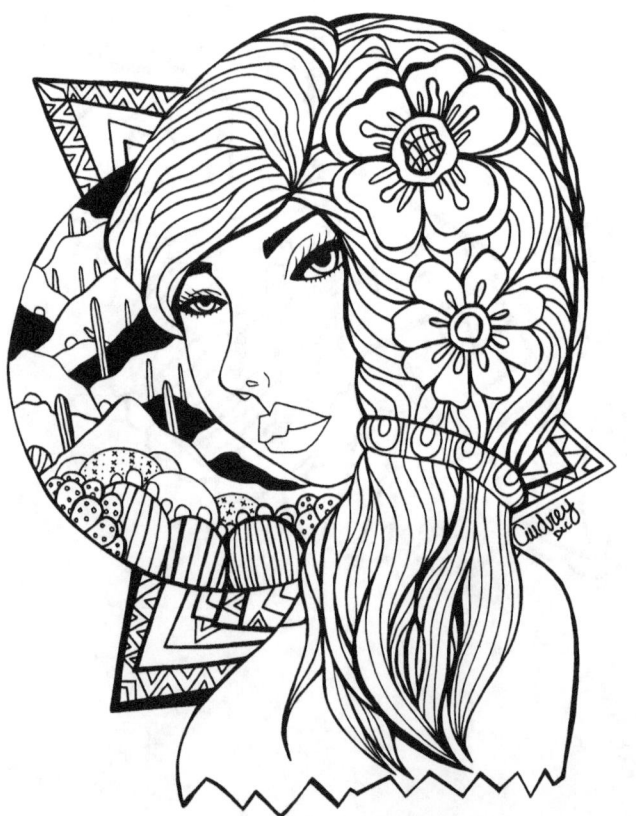

Connect With Me Online

Website	annotatedaudrey.com
Facebook	facebook.com/audreyannotates
Shop	annotatedaudreyart.storenvy.com
Instagram	@annotatedaudrey
Twitter	@annotatedaudrey

DESERT DAMES
& DOODLES

A Coloring Book Inspired by The Flora and Fauna of The Sonoran Desert

By Audrey De La Cruz

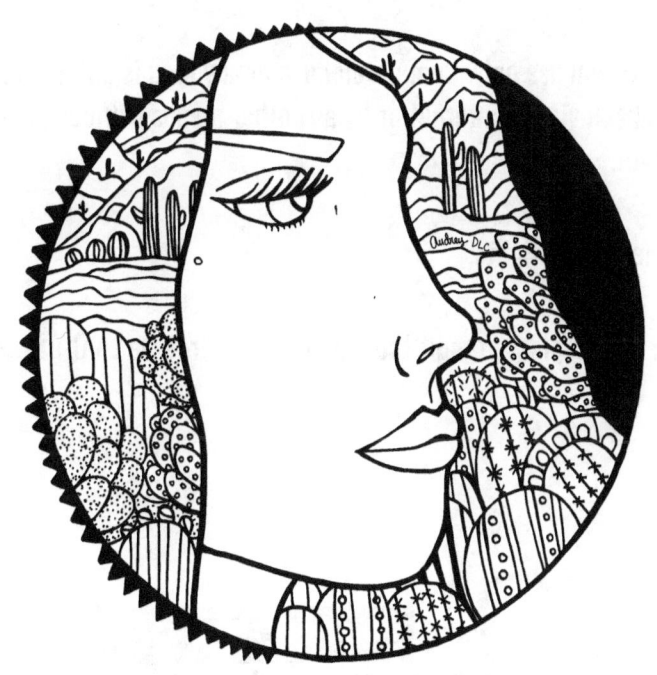

This book is dedicated to my family.
Your encouragement inspires me to work hard everyday to make my dreams come true.
I love you. Thank you for everything!

Illustrations and Text by Audrey De La Cruz (Annotated Audrey)

Editing & Design by Larry Andrade

All images Copyright © 2016 Audrey De La Cruz & Annotated Audrey Art. All rights reserved.

Many of these images were first shared on Audrey's blog (annotatedaudrey.com) and on her Instagram (instagram.com/annotatedaudrey) and other social media accounts.

The images in this book are for personal use only. Commercial use of any kind is not allowed. The scanning, uploading, and distributing of images in this book via the internet or by any other means without the permission of the copyright owner is a violation of the copyright.

Thanks so much for respecting the artist's rights.

If you post images that you color online, please credit the illustrator, Audrey De La Cruz (Annotated Audrey).

Introduction

In the spring of 2016, I moved from Los Angeles, California to Tucson, Arizona. While I lived in Los Angeles, my daily life was often composed of a collection of faces, buildings, vehicles and streets. While beautiful in its own right, my tiny place in the city lacked the natural surroundings that I craved to fuel my art. After moving to the desert, I began to feel inspired by the flora and fauna that surrounded me. When I looked outside my window, I saw birds, small mammals, cacti, and succulents of all varieties. Over time, I found myself incorporating more and more desert imagery into my art.

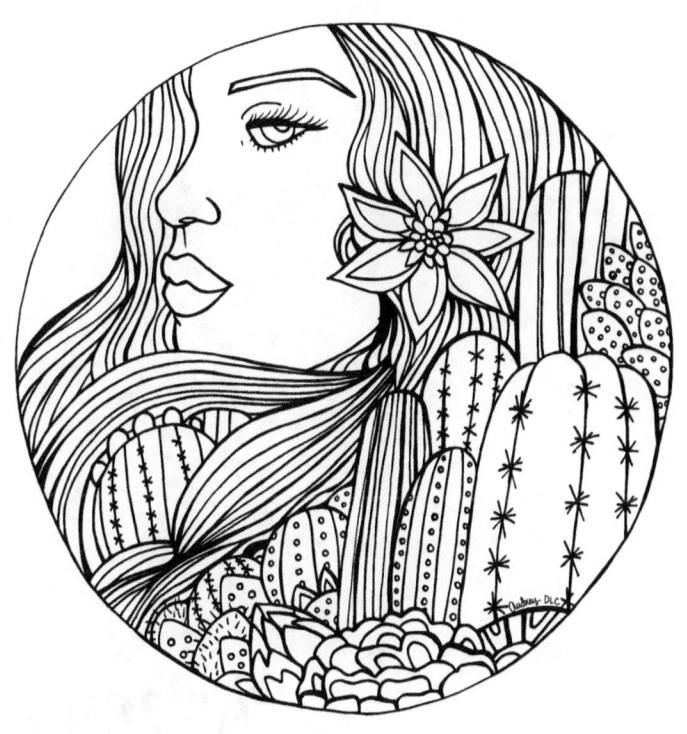

The first desert dame that I created was a pencil piece which I entitled, Desert Dweller. This piece captured the spirit of discovery and exploration that I felt when I first moved to the desert. **Desert Dames and Doodles** is an extension of that sentiment. These illustrations are inspired by the lush and majestic landscape of the Sonoran Desert and by the fascinating creatures that inhabit it. Just like the characters in my last book, **Feminine Florals**, these fierce females are inspired by people I know who have supported my artistic journey in some way.

Coloring Tips:

- You can use a variety of artistic media to color this book. Crayons, gel pens, colored pencils and markers are great options. I love to color with a mix of different media in the same art piece. I would not recommend using wet media, such as watercolor, in this book.

- To keep the pages clean, place several sheets of paper between the page you are coloring and the next. This tip is especially important if you decide to use markers or pens to color your artwork.

- It's always a good idea to test your art supplies on a coloring book before you begin a new coloring masterpiece. You can test your materials by coloring the small images at the beginning of the book. As always, make sure to put a piece of paper between the page you are coloring and the next page.

- There are no set rules. Have fun, relax and get creative!

- For more coloring tips and tricks, visit my website at anntoatedaudrey.com.

Arizona Royalty

Copyright. Audrey De La Cruz (Annotated Audrey). 2016 ©

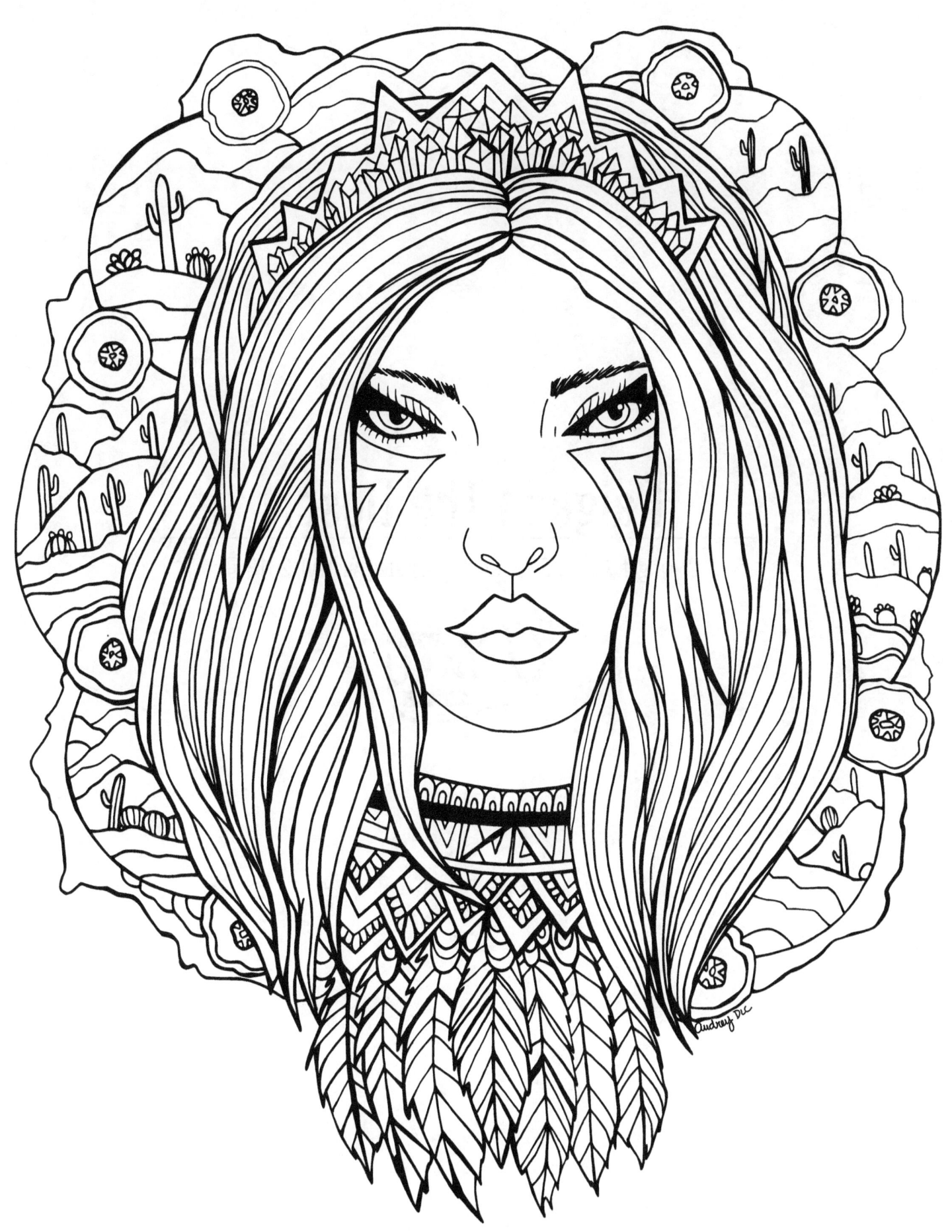

Paige in The Desert

Copyright. Audrey De La Cruz (Annotated Audrey). 2016 ©

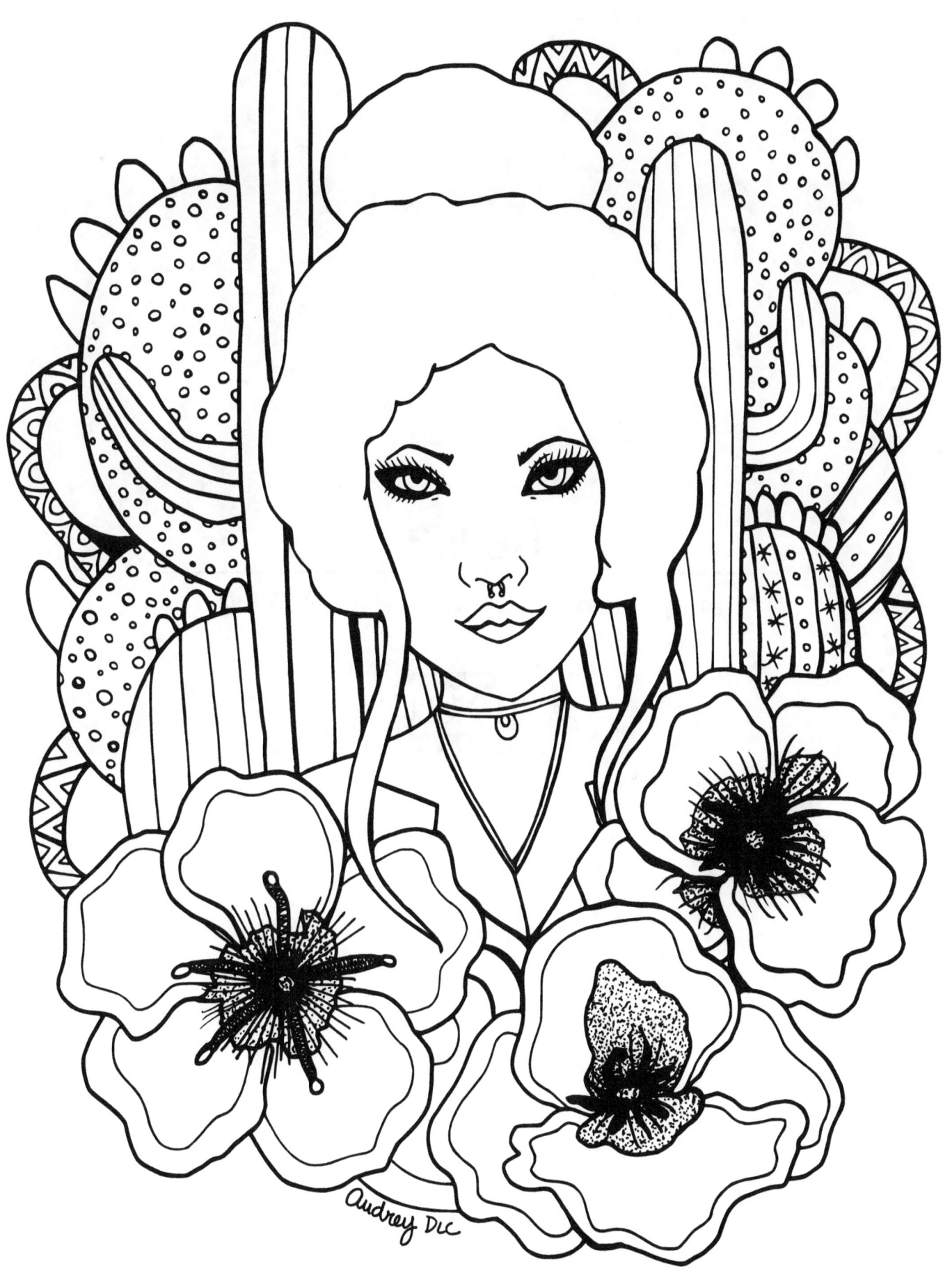

Nelvia

Copyright. Audrey De La Cruz (Annotated Audrey). 2016 ©

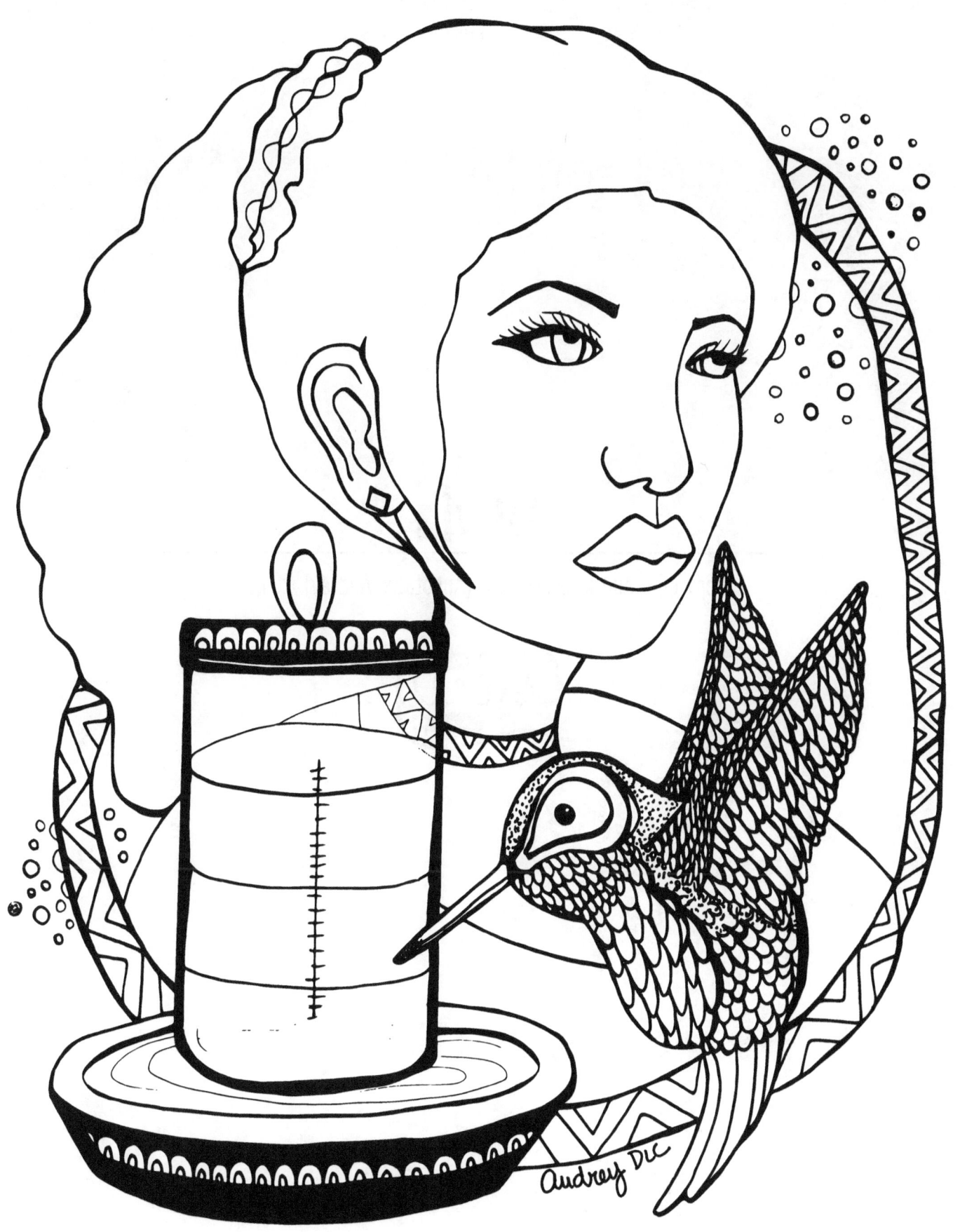

Olivia

Copyright. Audrey De La Cruz (Annotated Audrey). 2016 ©

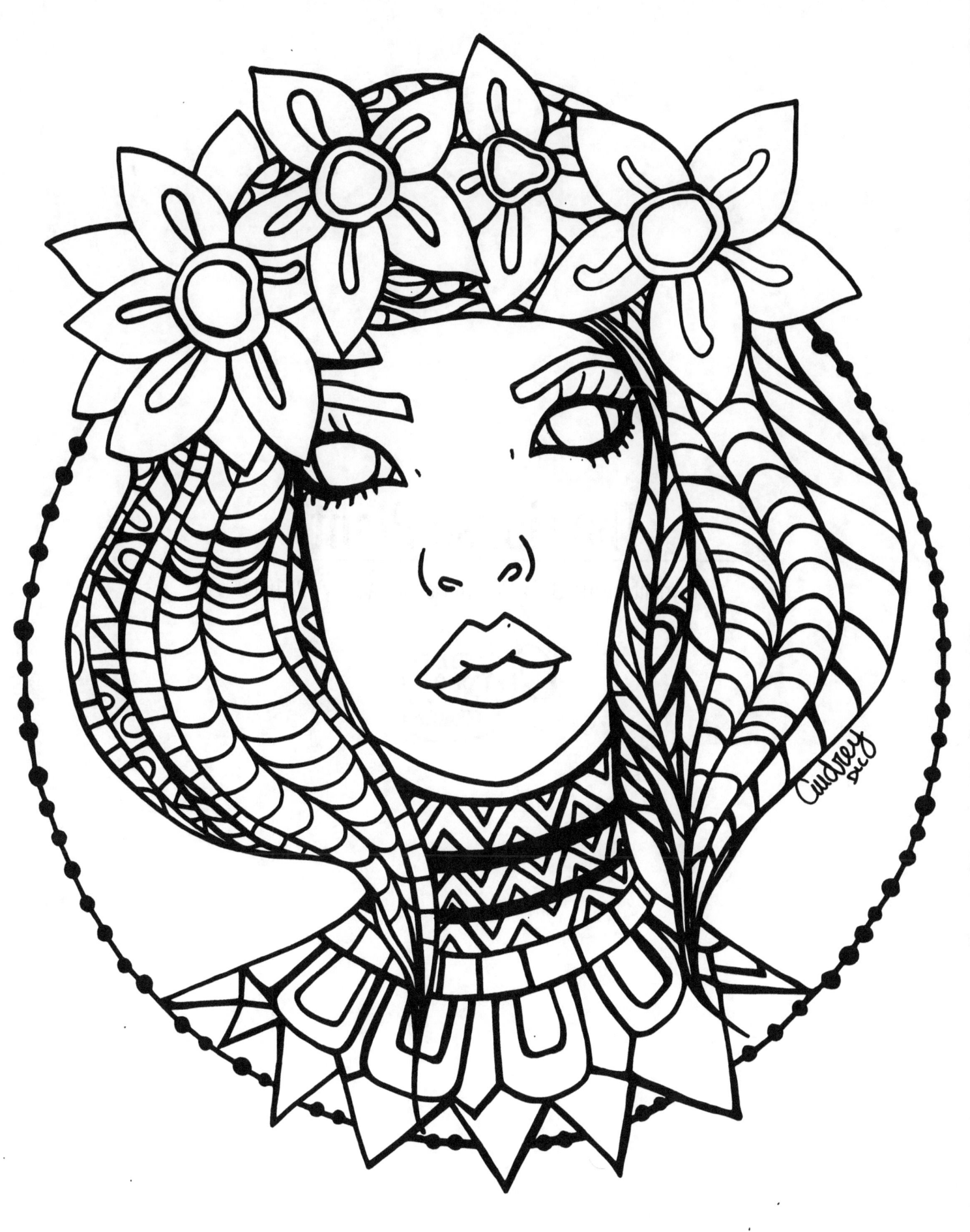

The House Plant

Copyright. Audrey De La Cruz (Annotated Audrey). 2016 ©

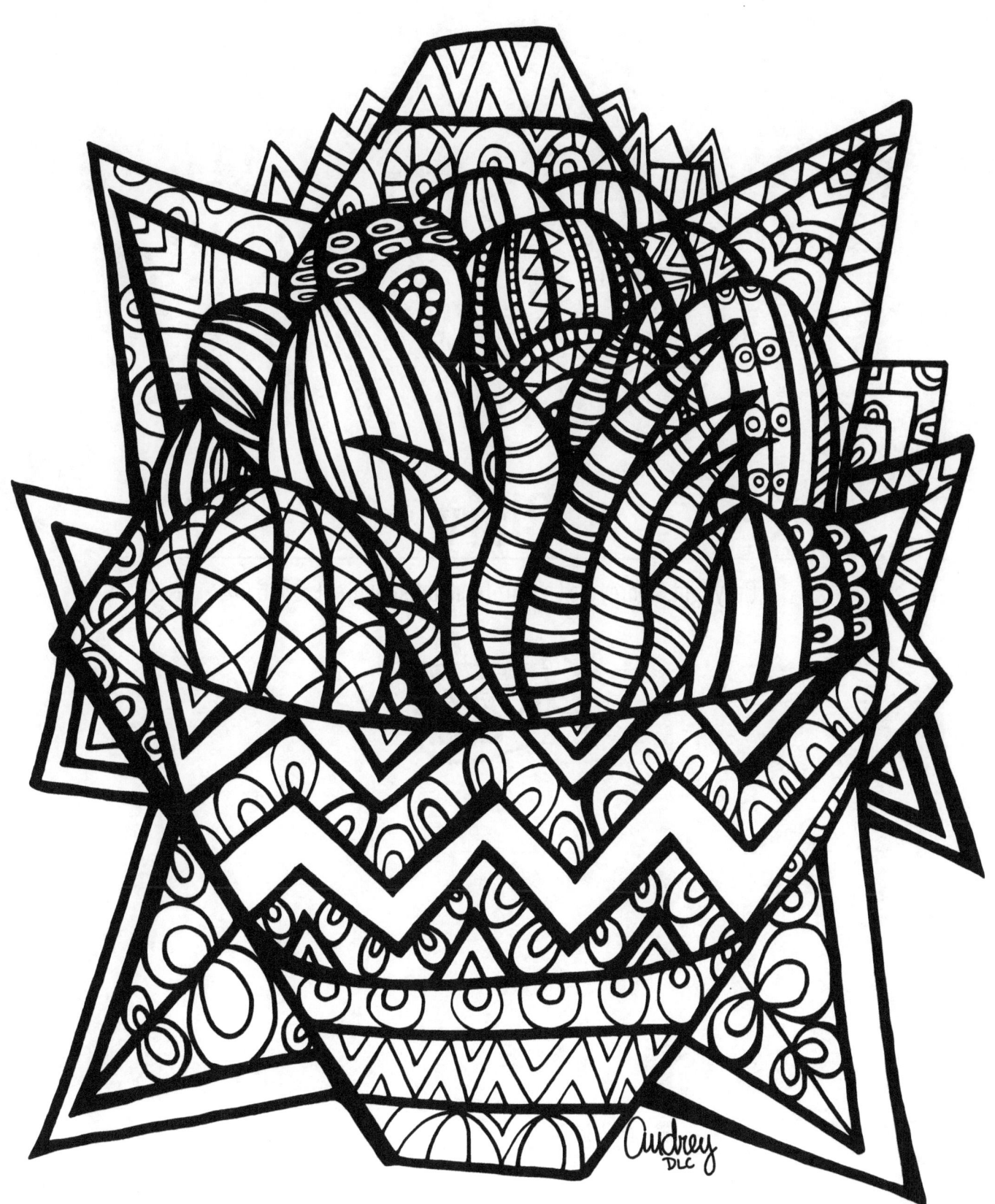

Clary

Copyright. Audrey De La Cruz (Annotated Audrey). 2016 ©

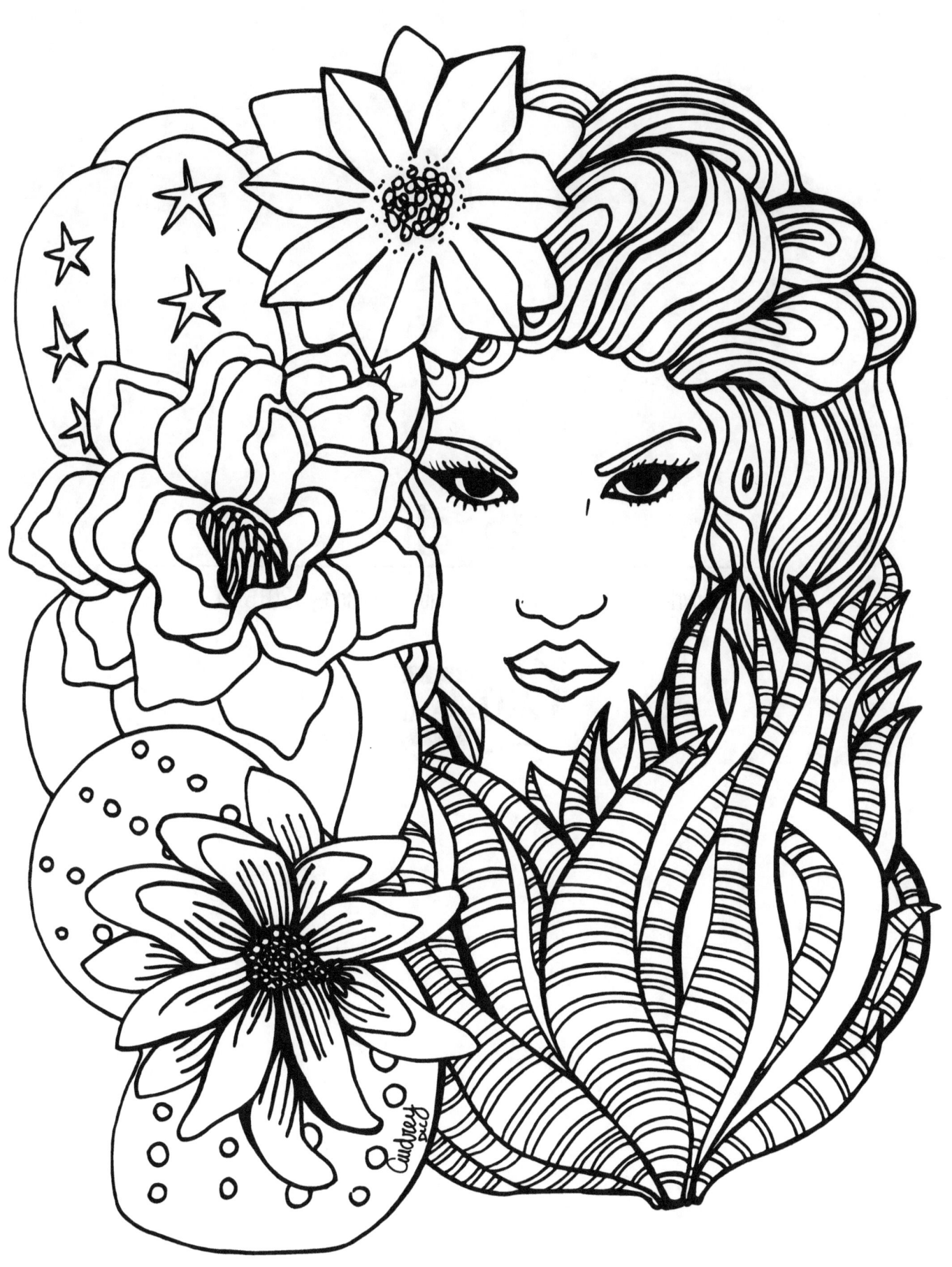

Magali

Copyright. Audrey De La Cruz (Annotated Audrey). 2016 ©

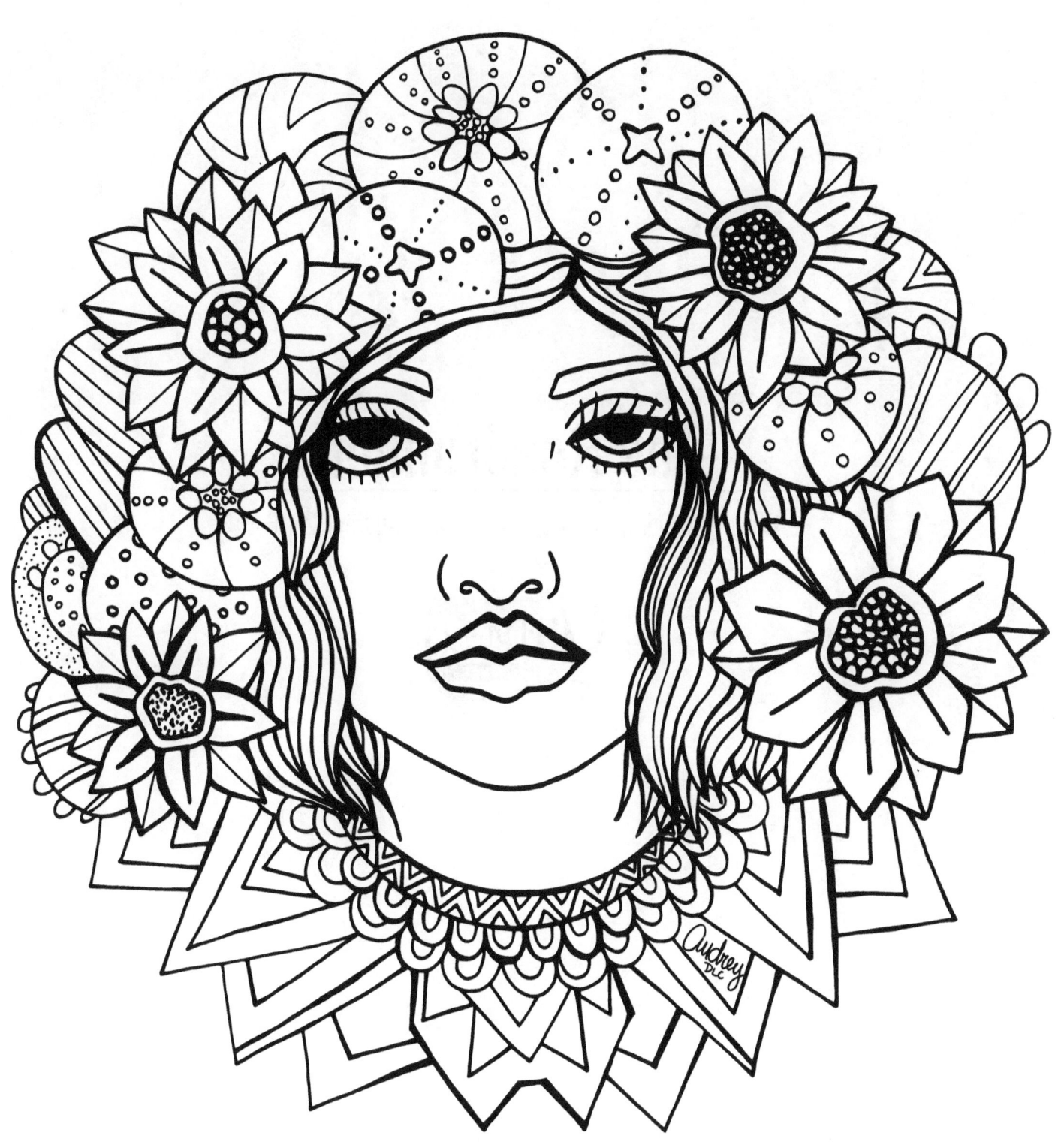

The Roadrunner

Copyright. Audrey De La Cruz (Annotated Audrey). 2016 ©

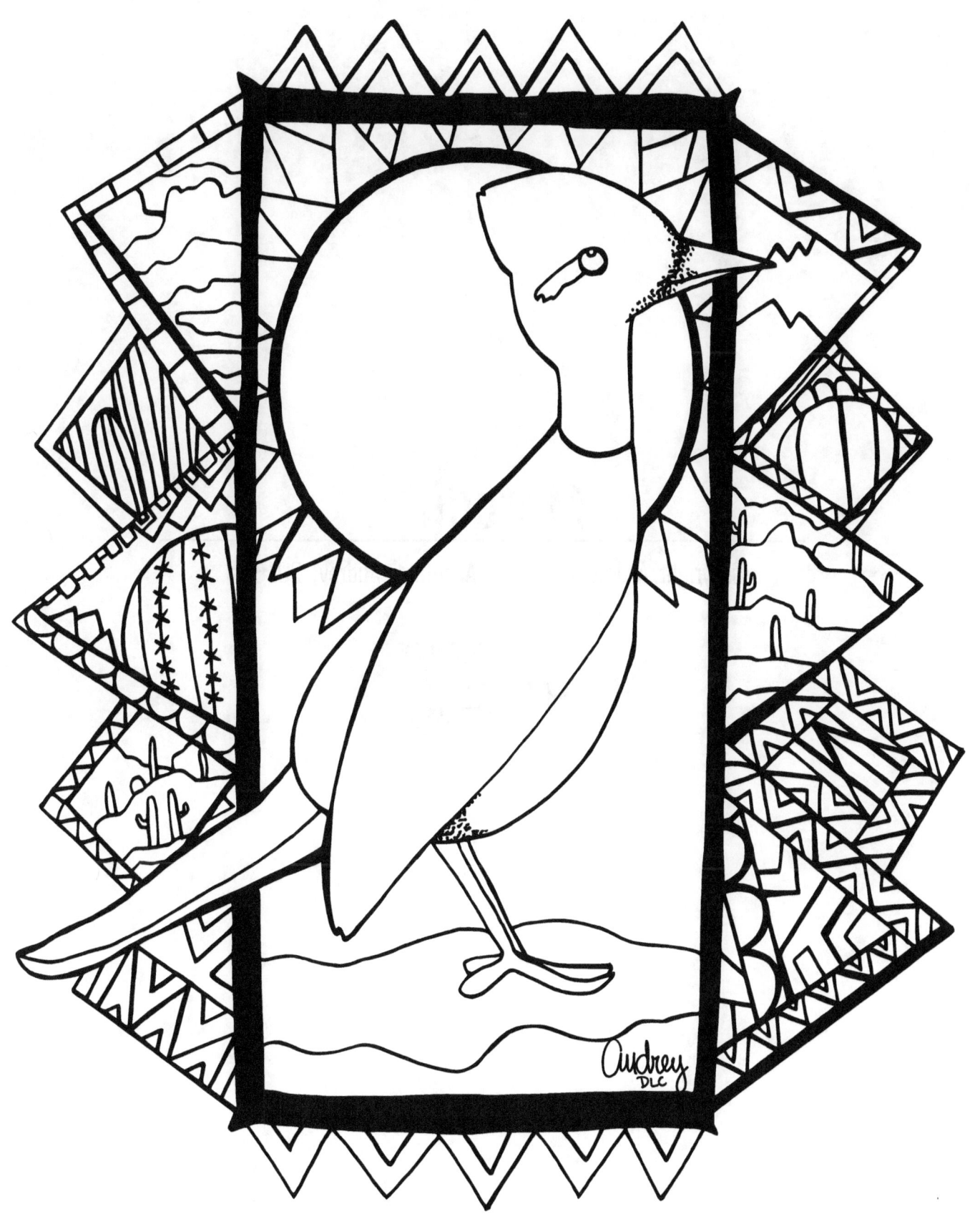

Marcela

Copyright. Audrey De La Cruz (Annotated Audrey). 2016 ©

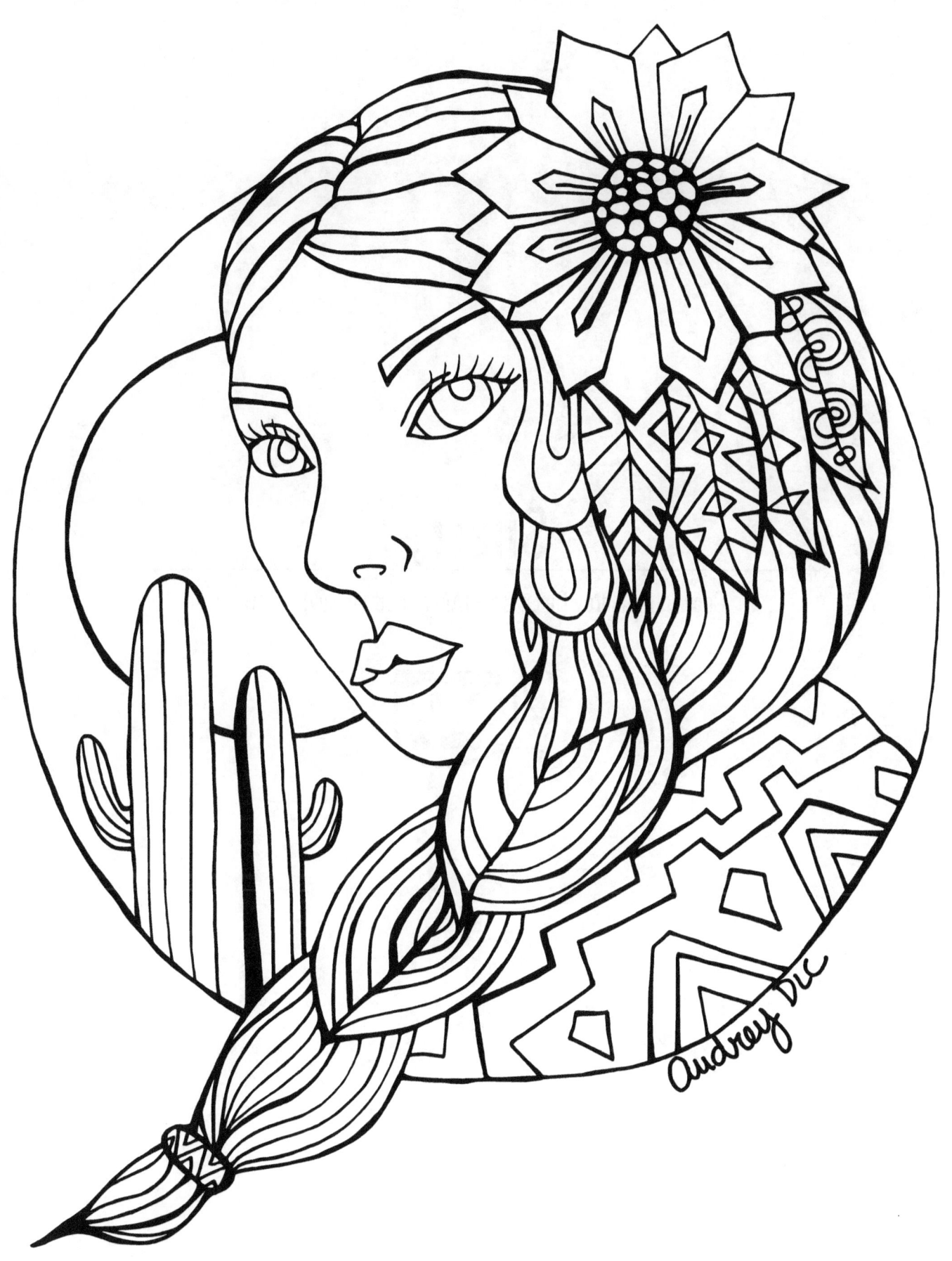

Sherry

Copyright. Audrey De La Cruz (Annotated Audrey). 2016 ©

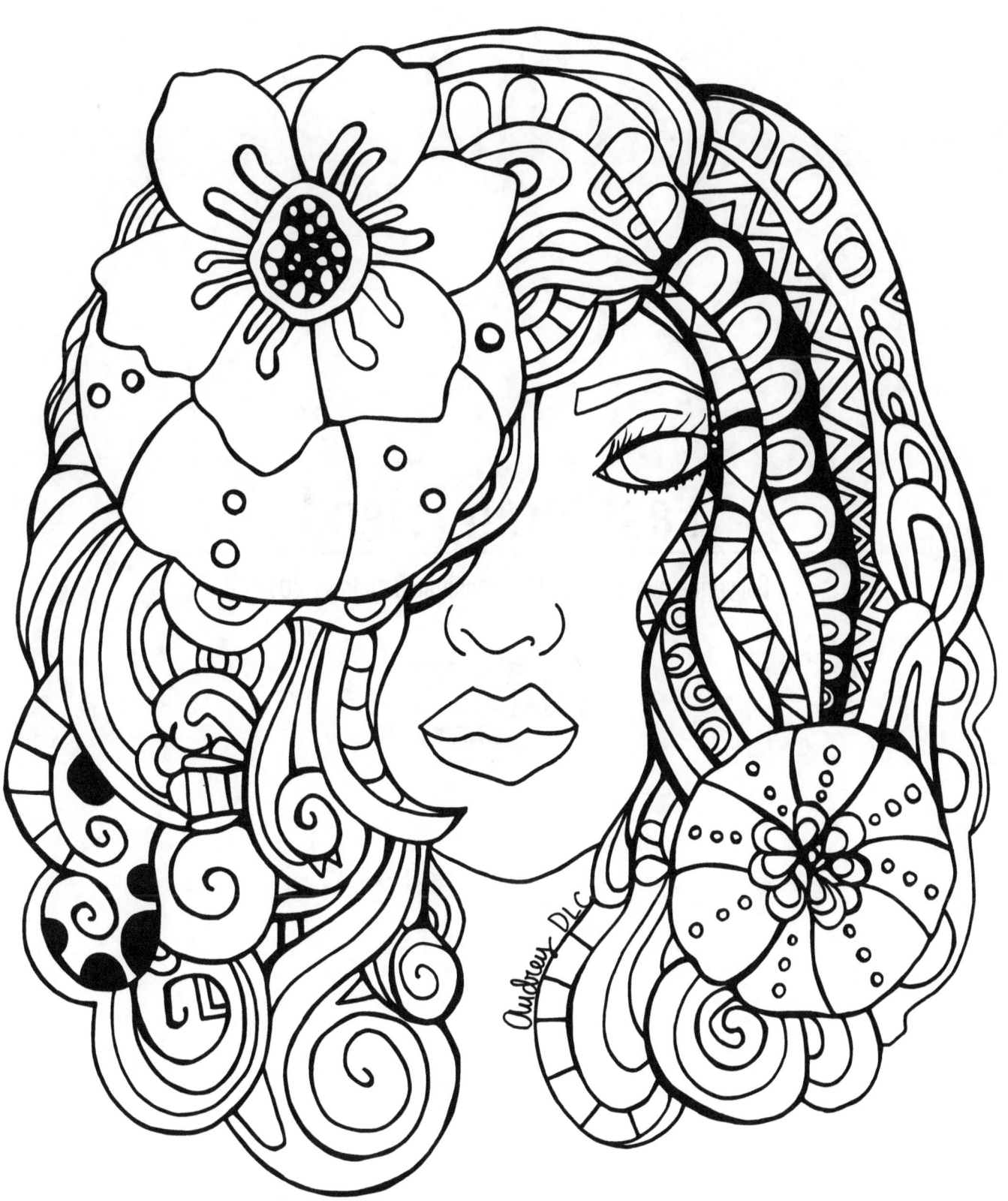

Feathered Friend

Copyright. Audrey De La Cruz (Annotated Audrey). 2016 ©

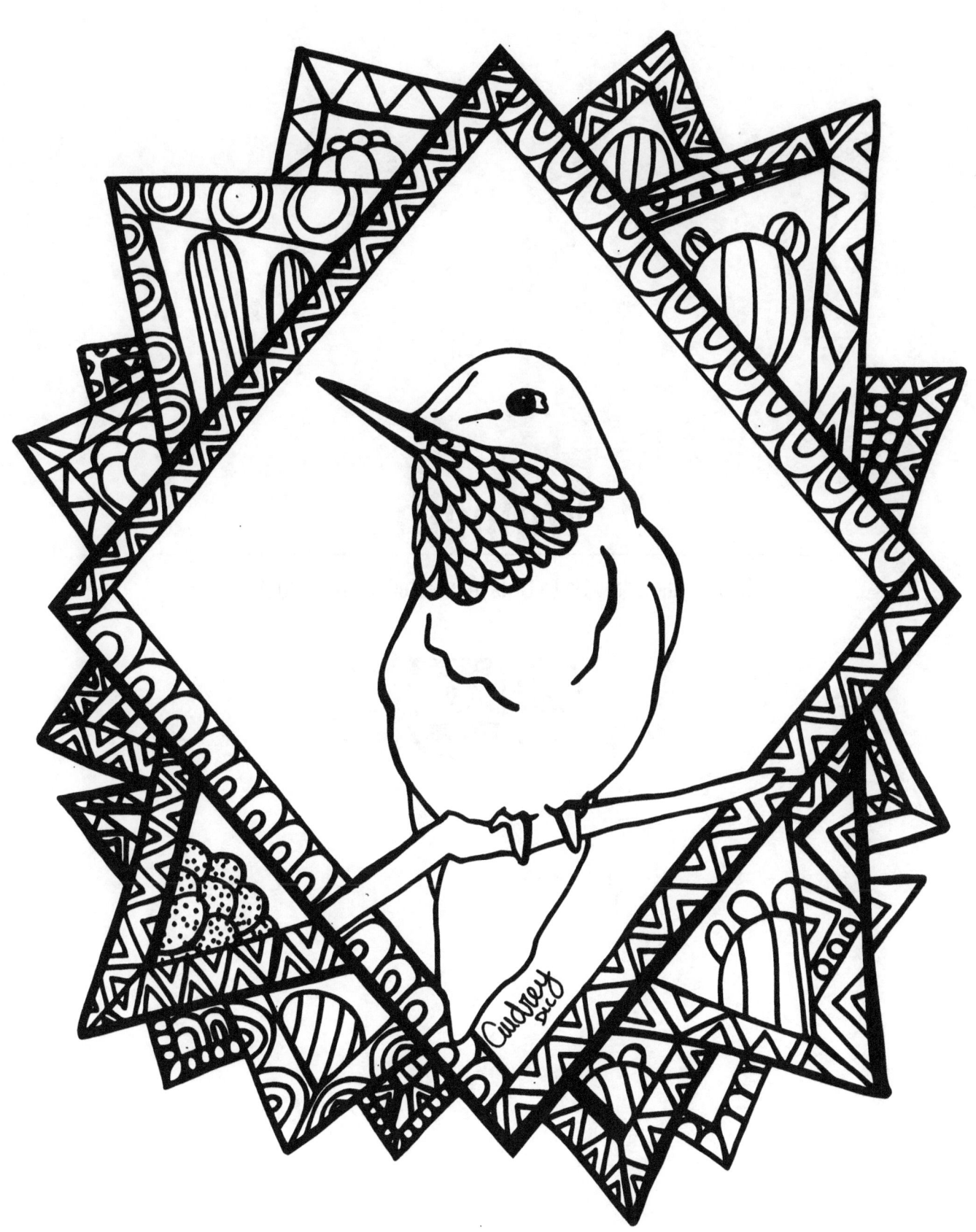

Winneth

Copyright. Audrey De La Cruz (Annotated Audrey). 2016 ©

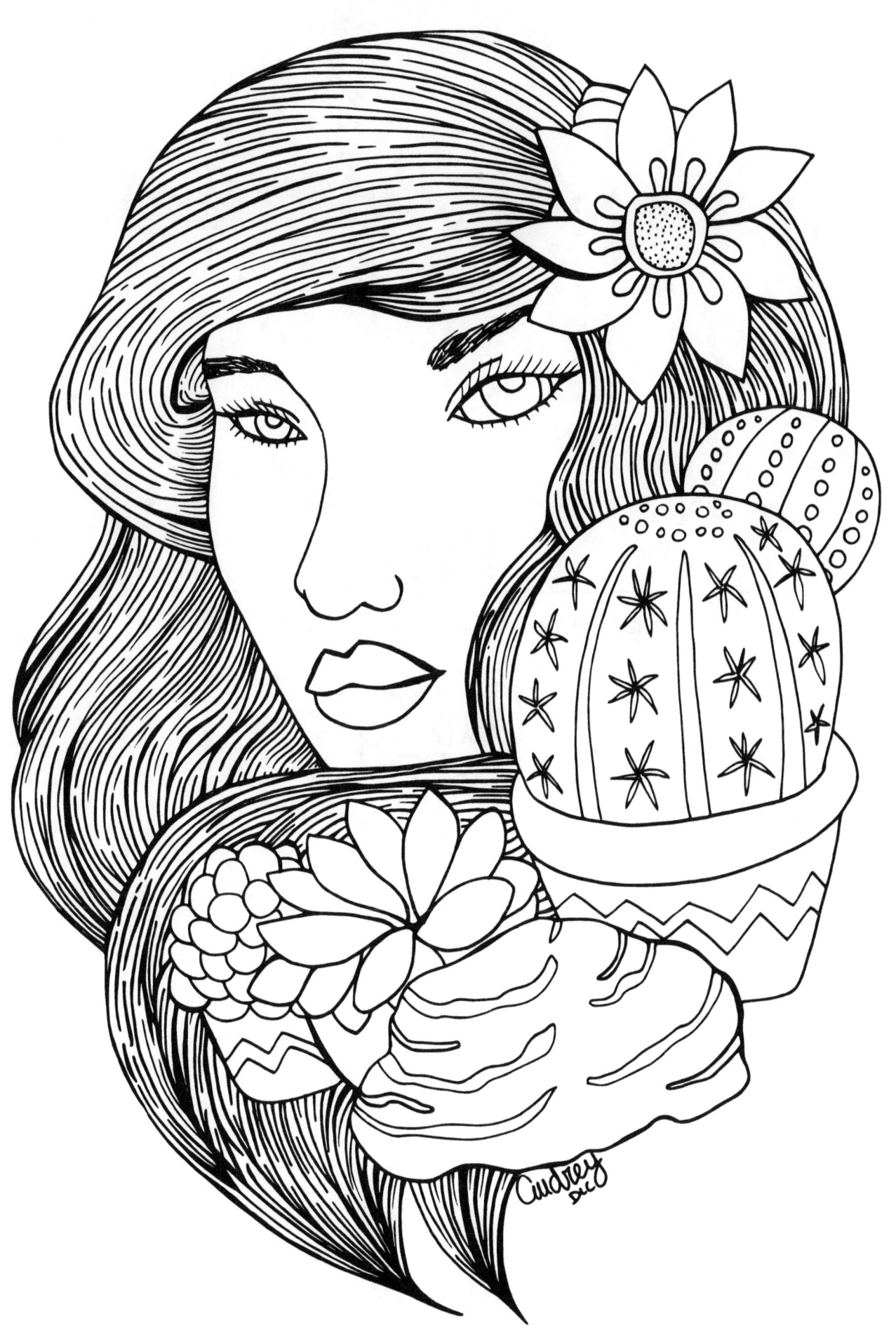

Hong

Copyright. Audrey De La Cruz (Annotated Audrey). 2016 ©

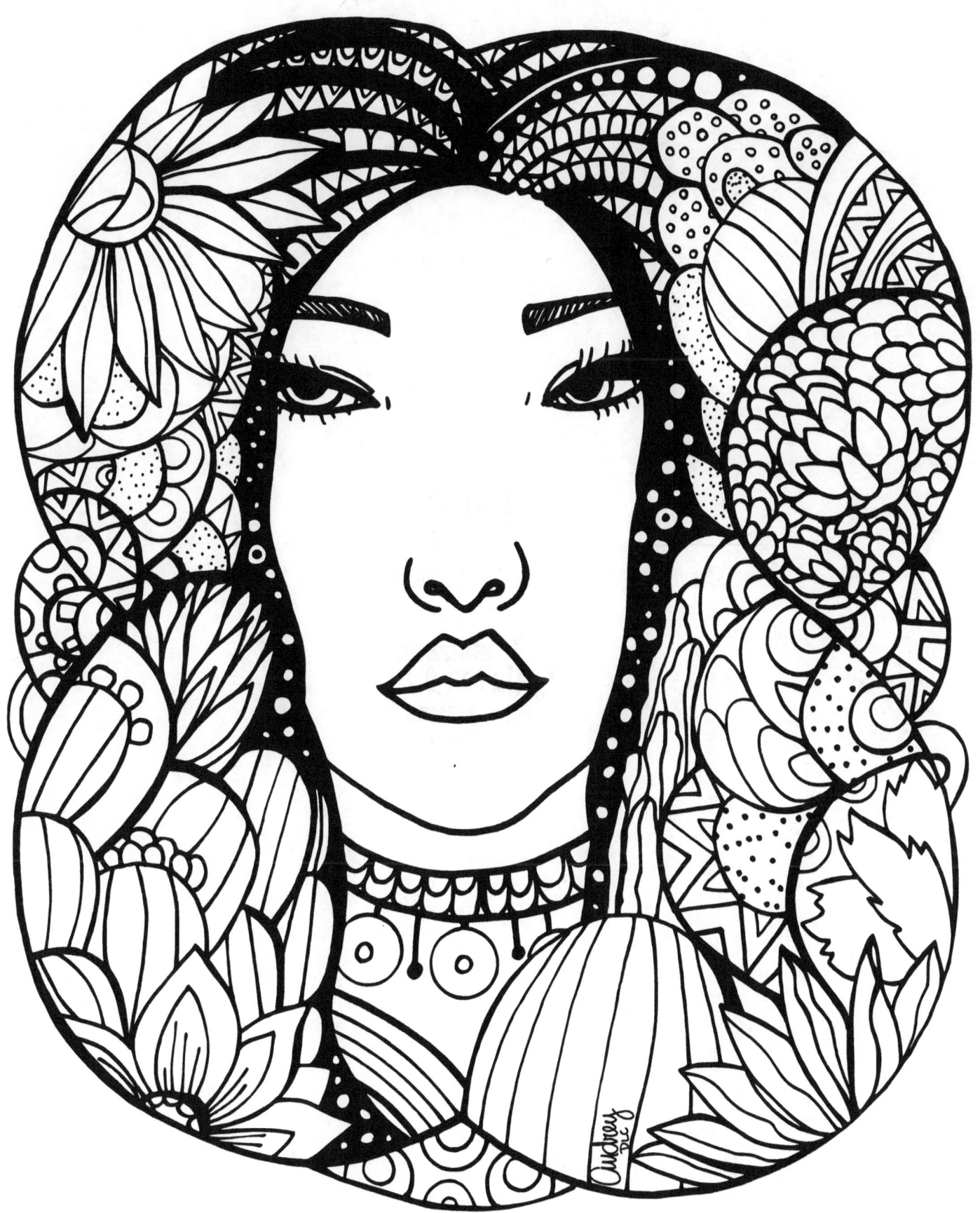

Jane

Copyright. Audrey De La Cruz (Annotated Audrey). 2016 ©

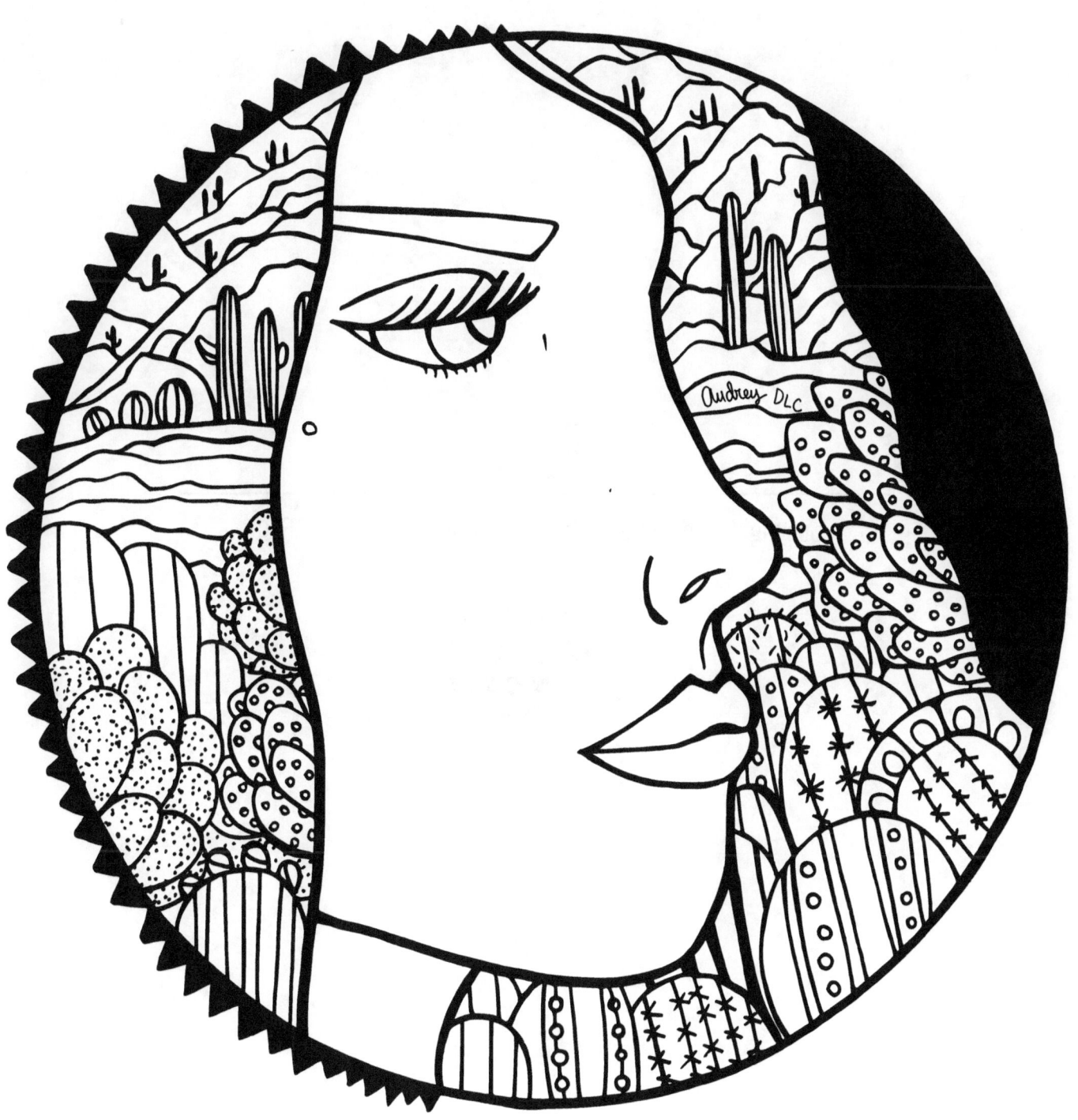

Eris

Copyright. Audrey De La Cruz (Annotated Audrey). 2016 ©

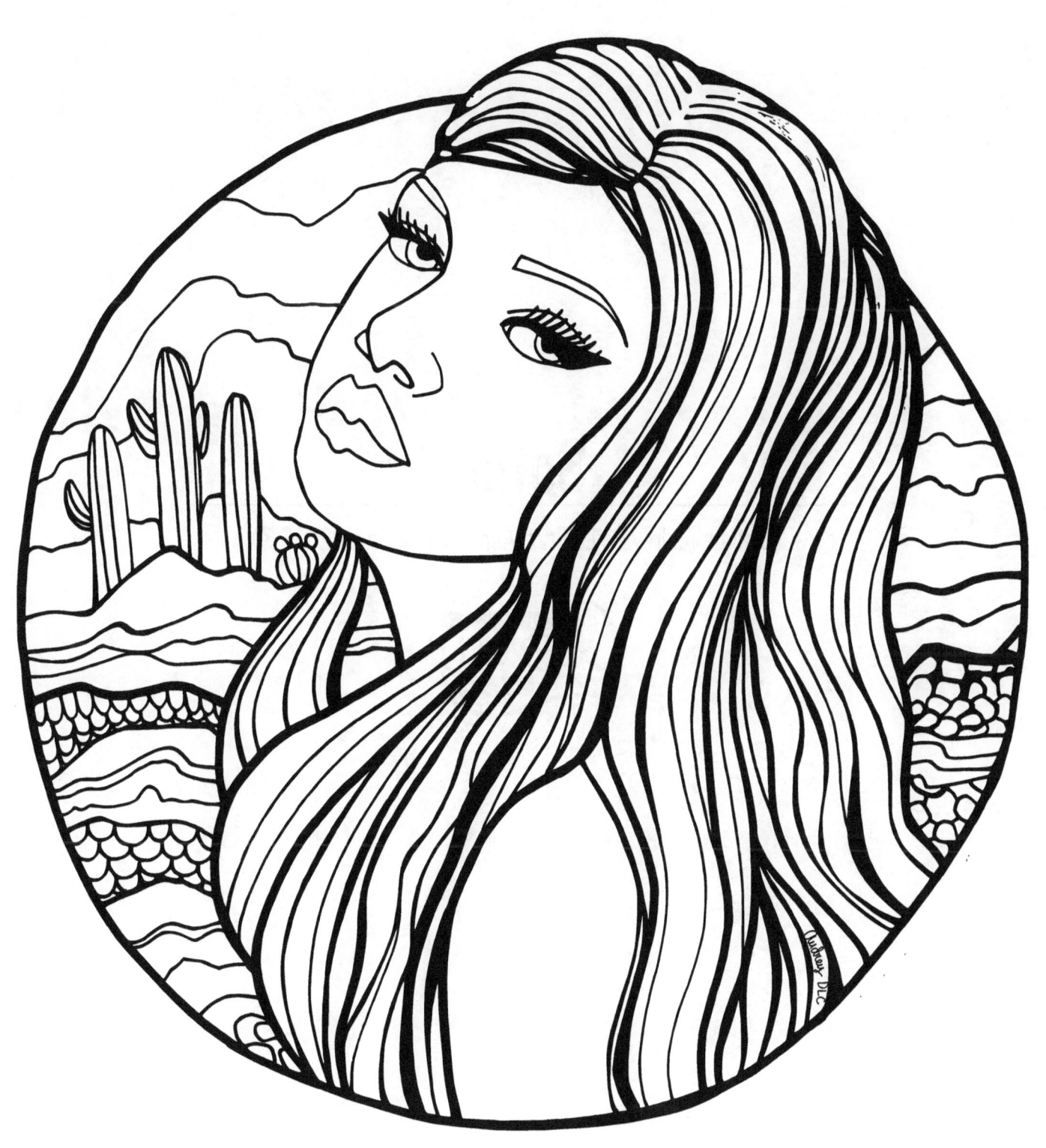

Sofia

Copyright. Audrey De La Cruz (Annotated Audrey). 2016 ©

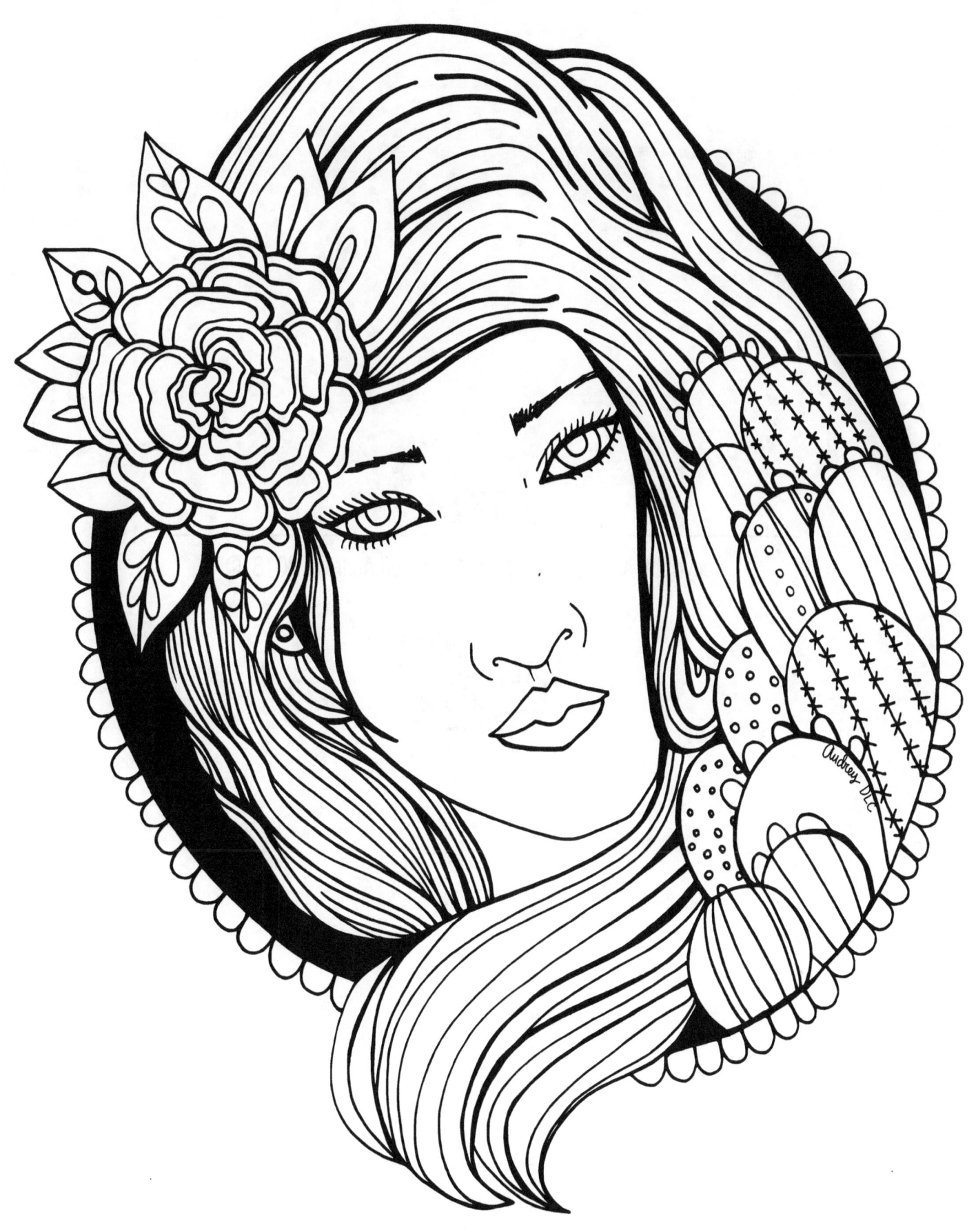

Jakie

Copyright. Audrey De La Cruz (Annotated Audrey). 2016 ©

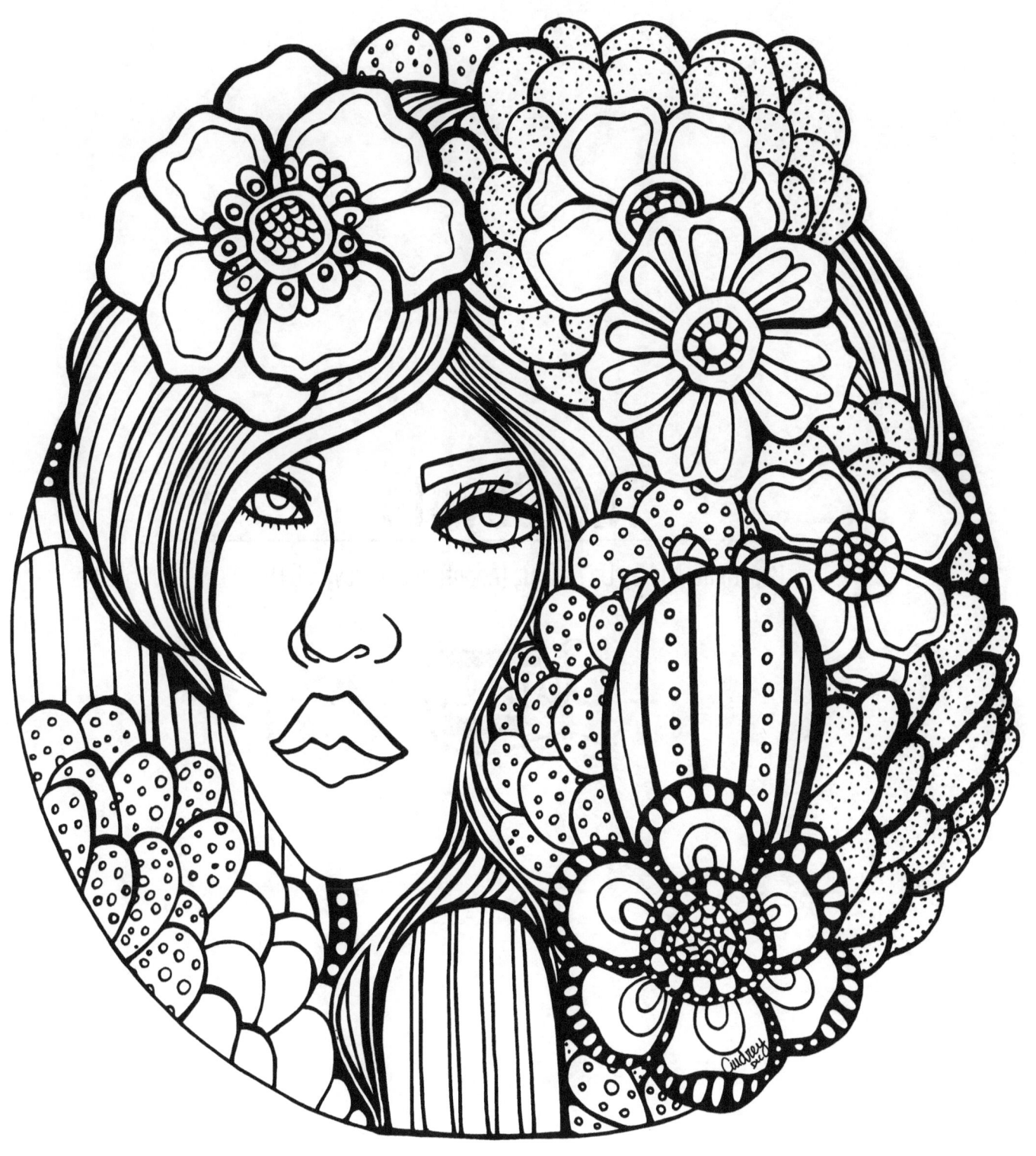

The Coyote

Copyright. Audrey De La Cruz (Annotated Audrey). 2016 ©

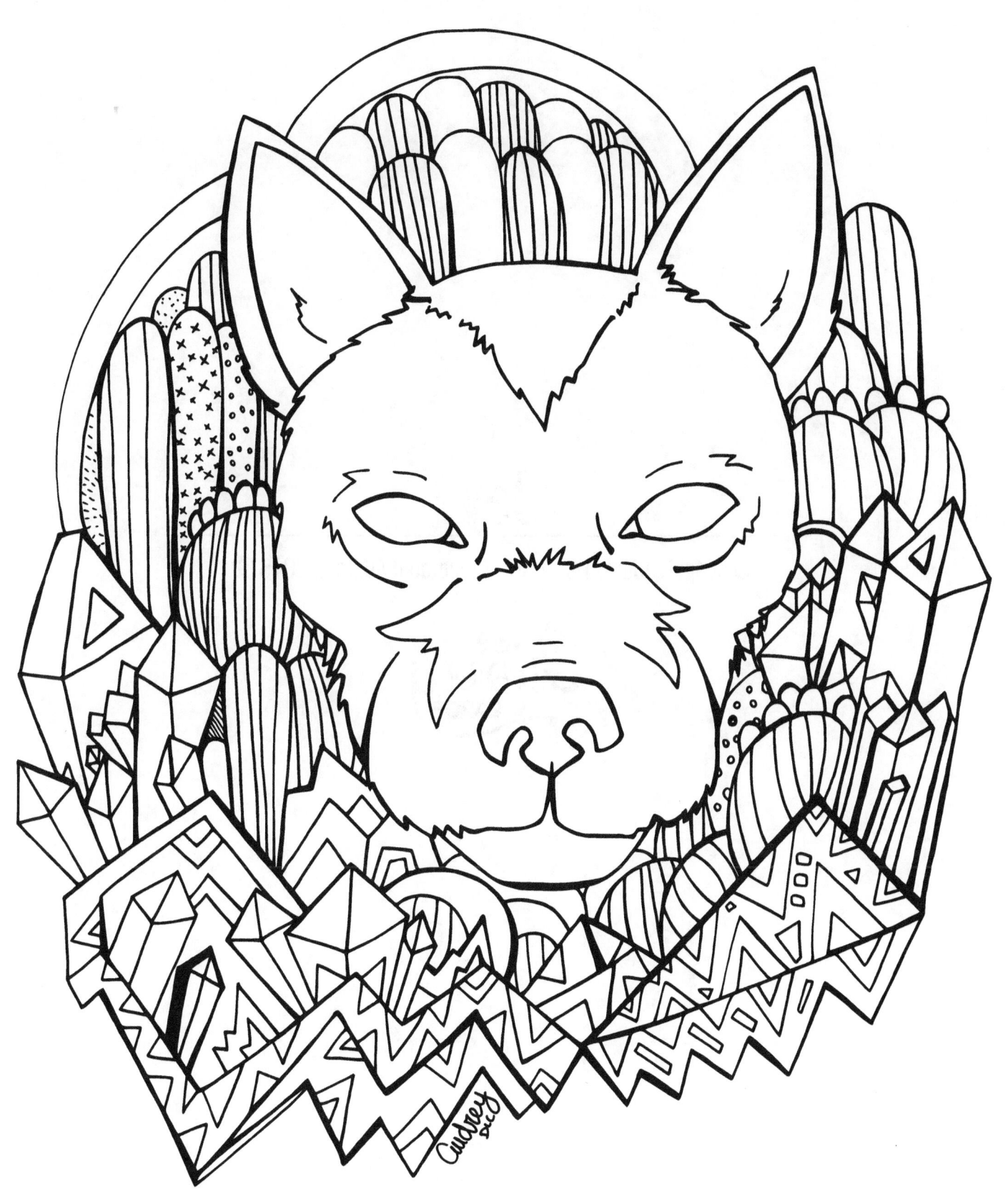

Jay

Copyright. Audrey De La Cruz (Annotated Audrey). 2016 ©

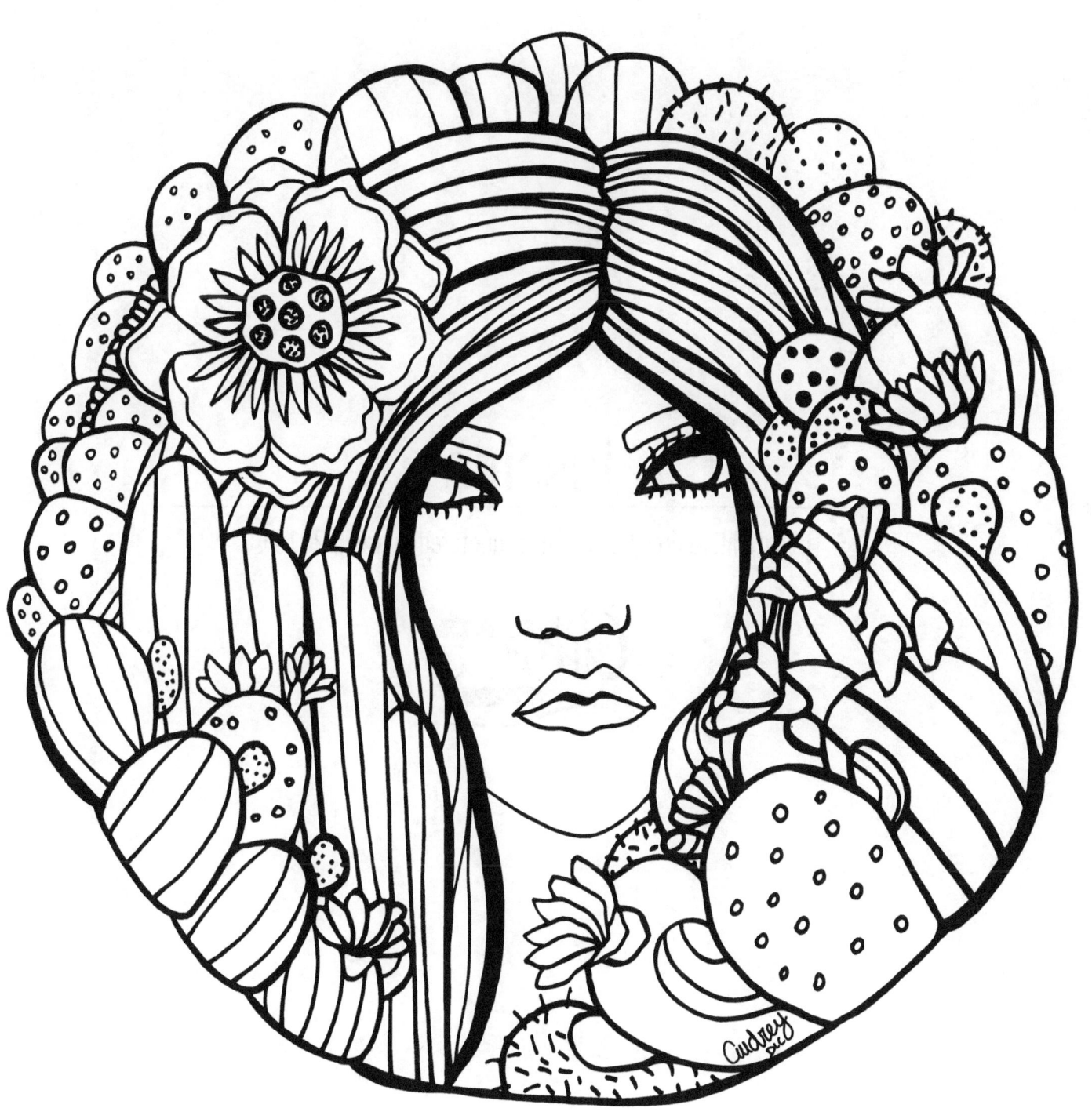

Jessica

Copyright. Audrey De La Cruz (Annotated Audrey). 2016 ©

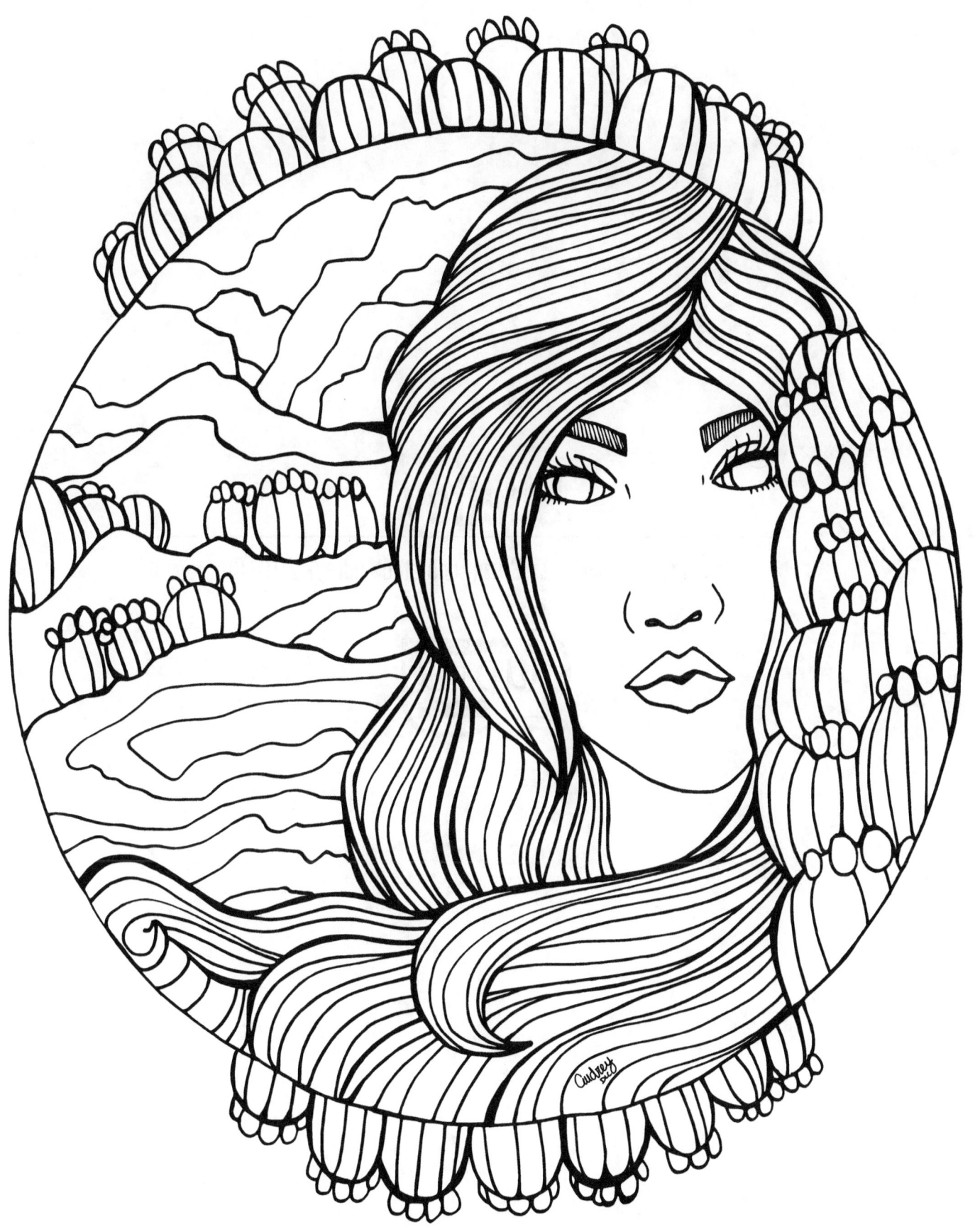

Shelley

Copyright. Audrey De La Cruz (Annotated Audrey). 2016 ©

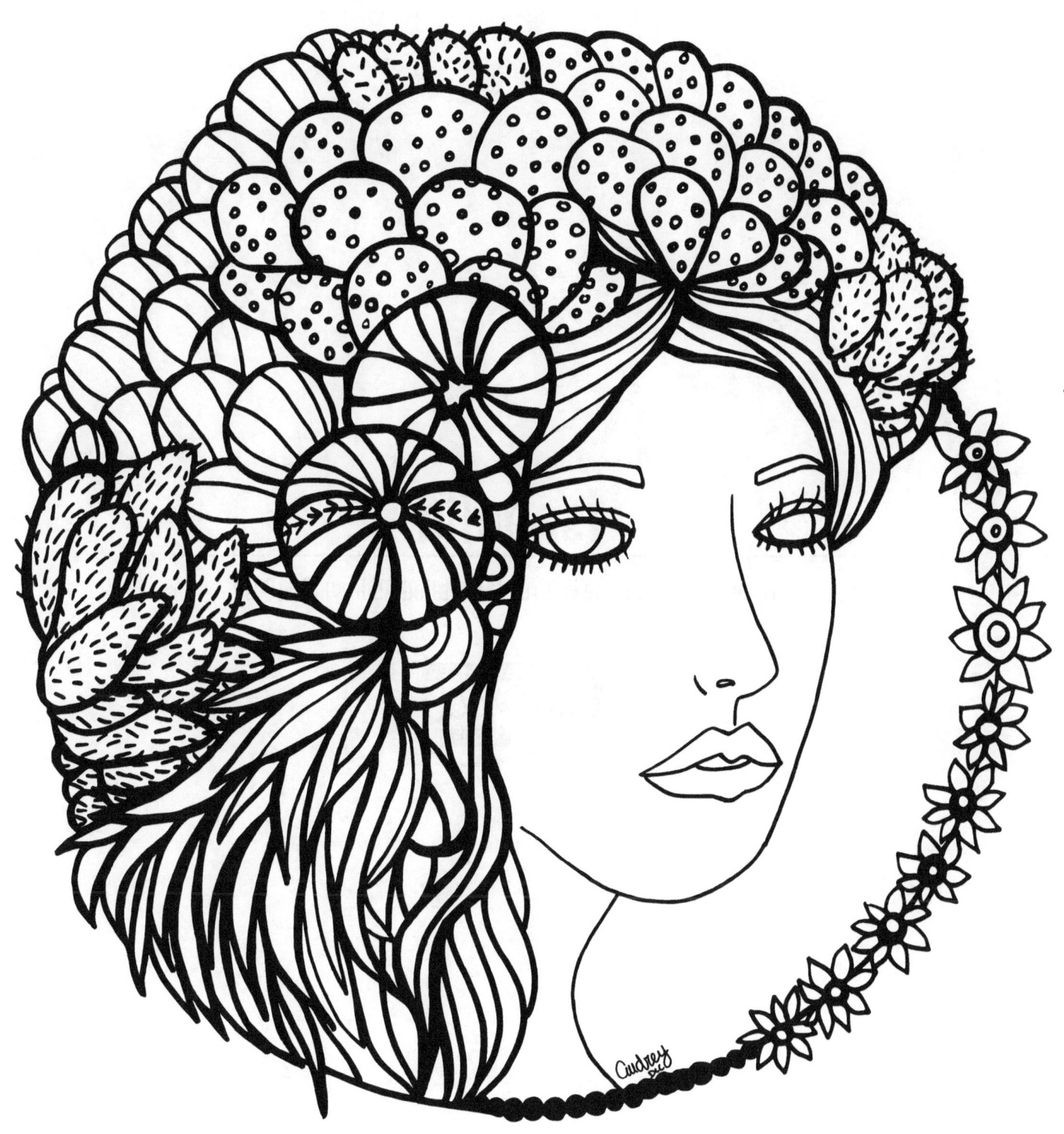

Isabella

Copyright. Audrey De La Cruz (Annotated Audrey). 2016 ©

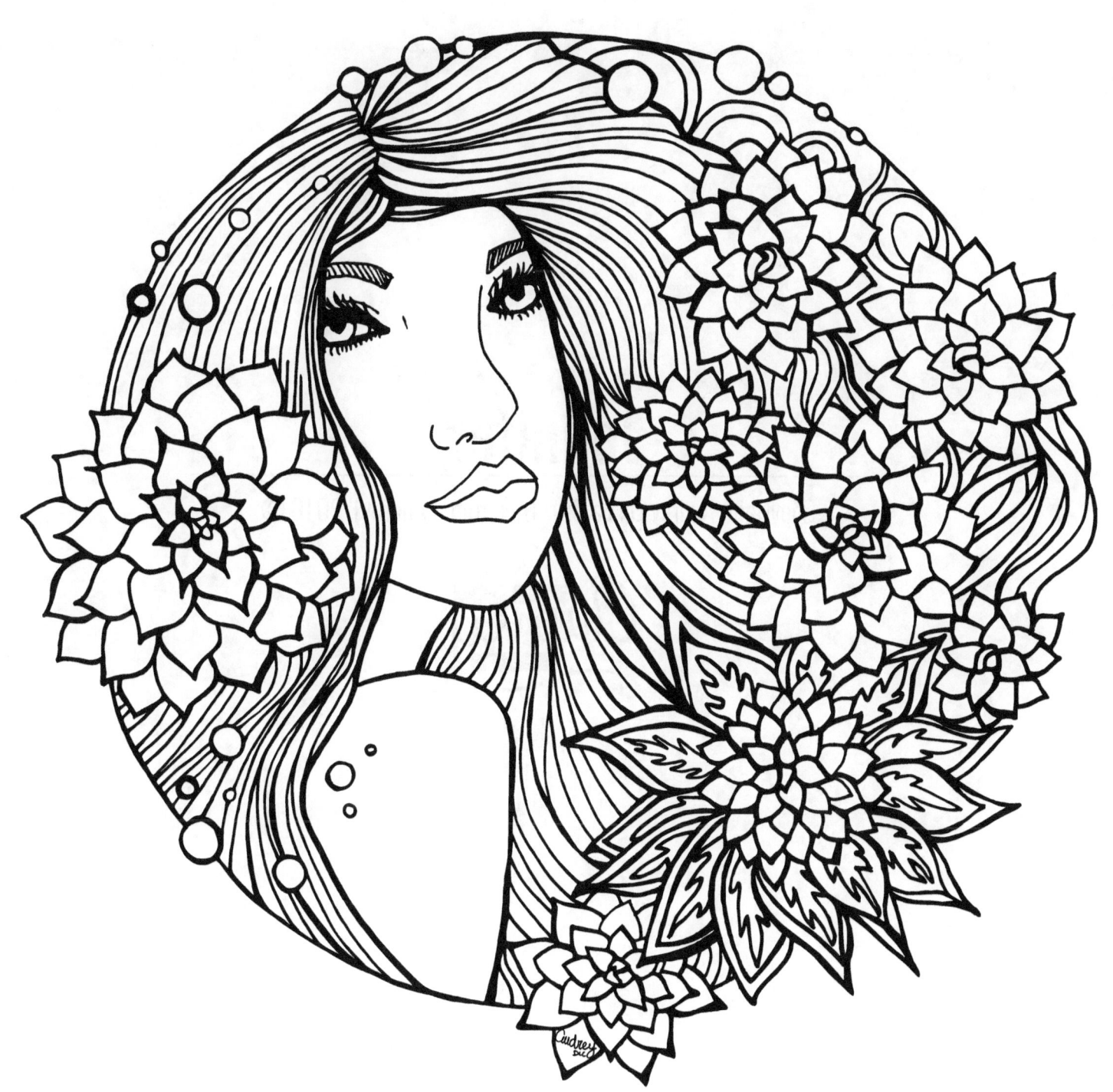

Jennifer

Copyright. Audrey De La Cruz (Annotated Audrey). 2016 ©

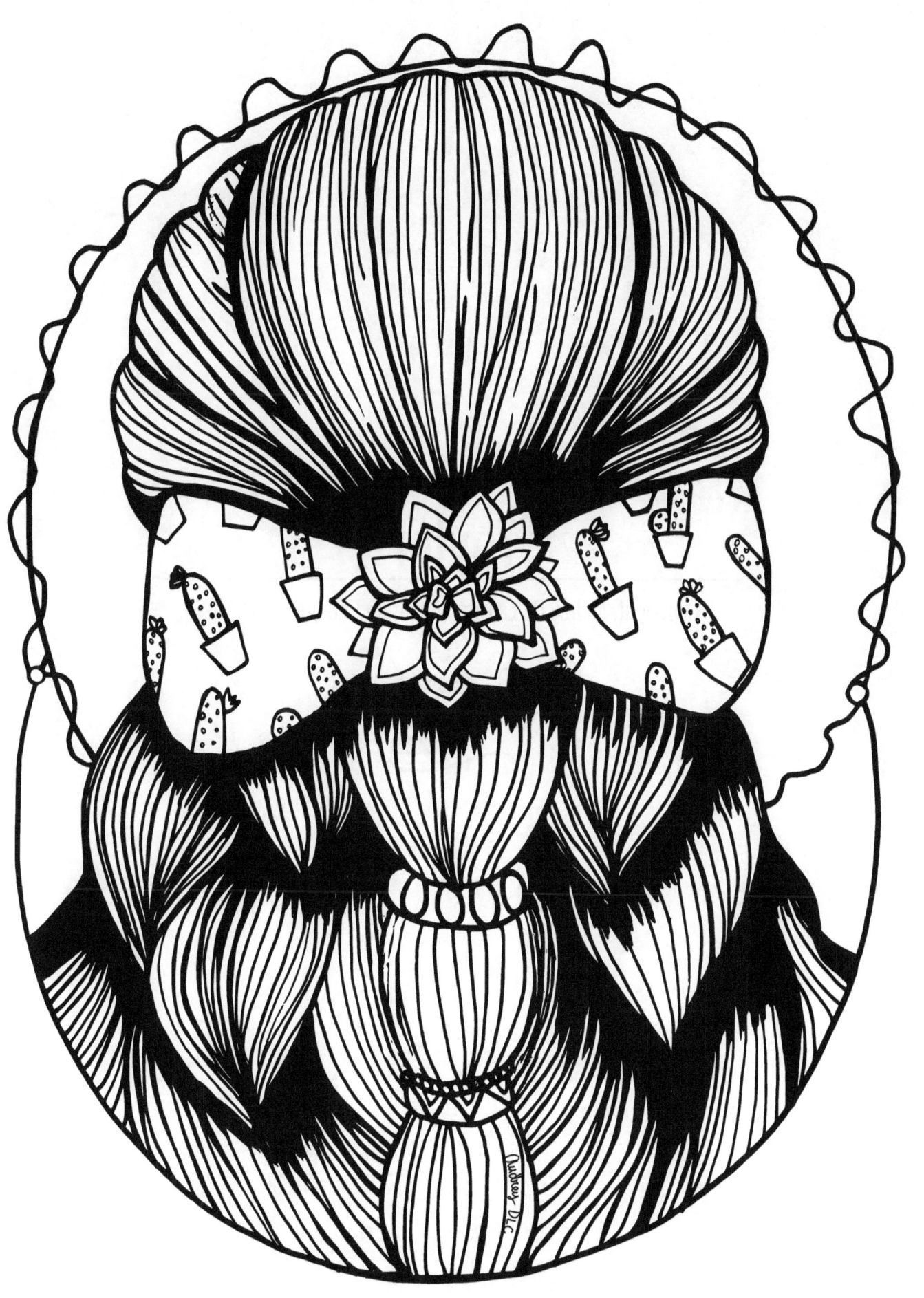

Taylor

Copyright. Audrey De La Cruz (Annotated Audrey). 2016 ©

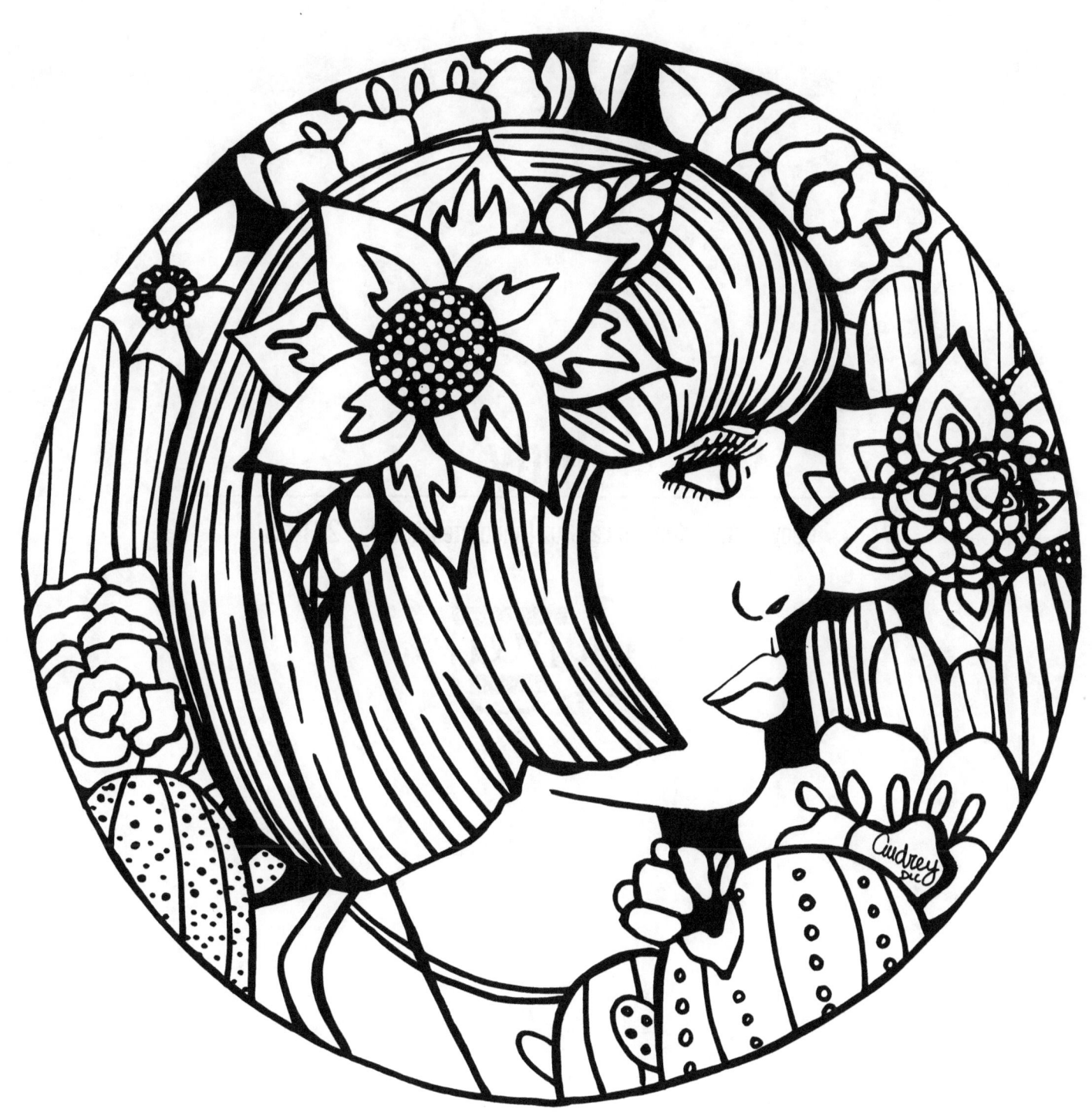

Judy

Copyright. Audrey De La Cruz (Annotated Audrey). 2016 ©

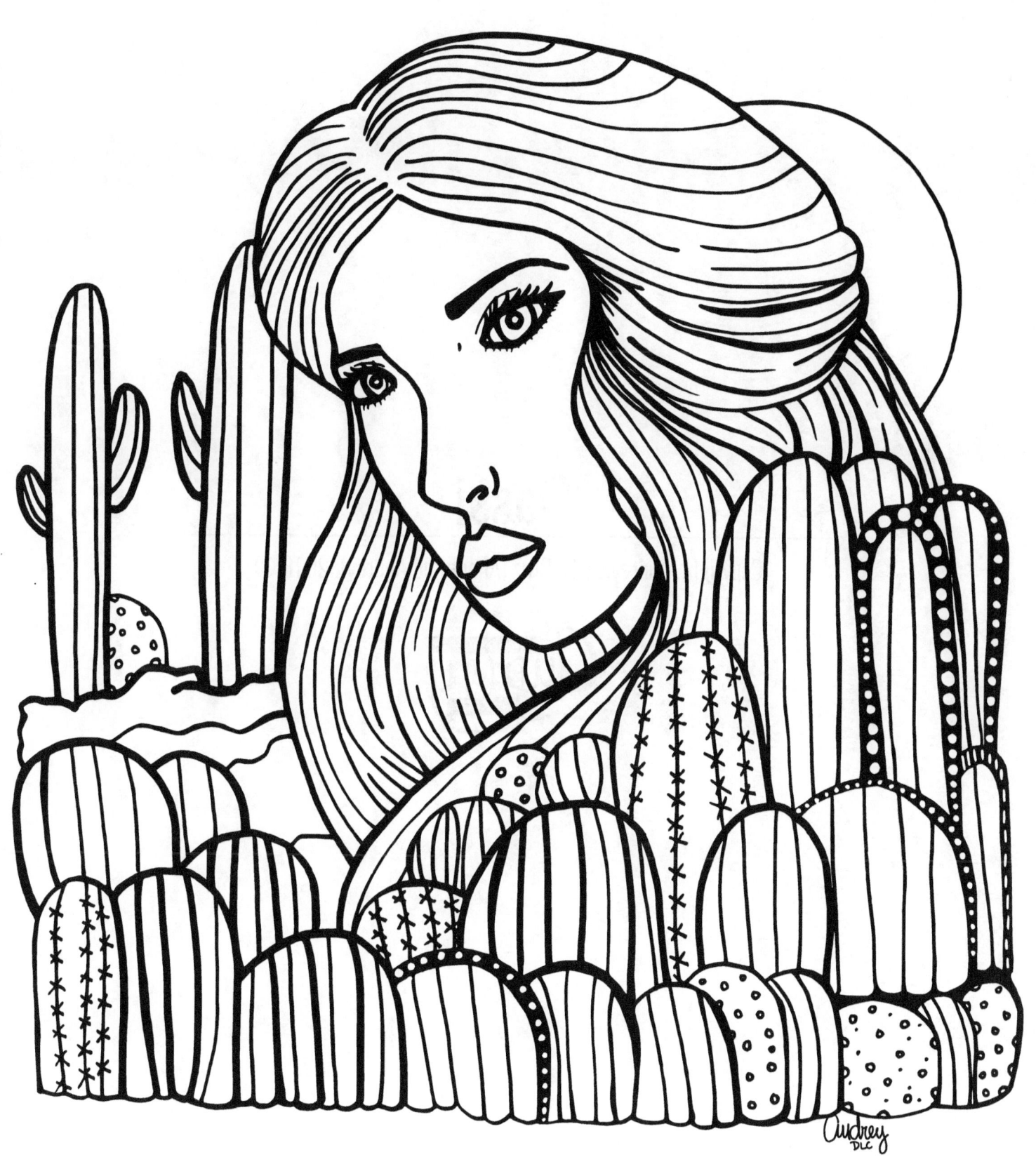

Cassi

Copyright. Audrey De La Cruz (Annotated Audrey). 2016 ©

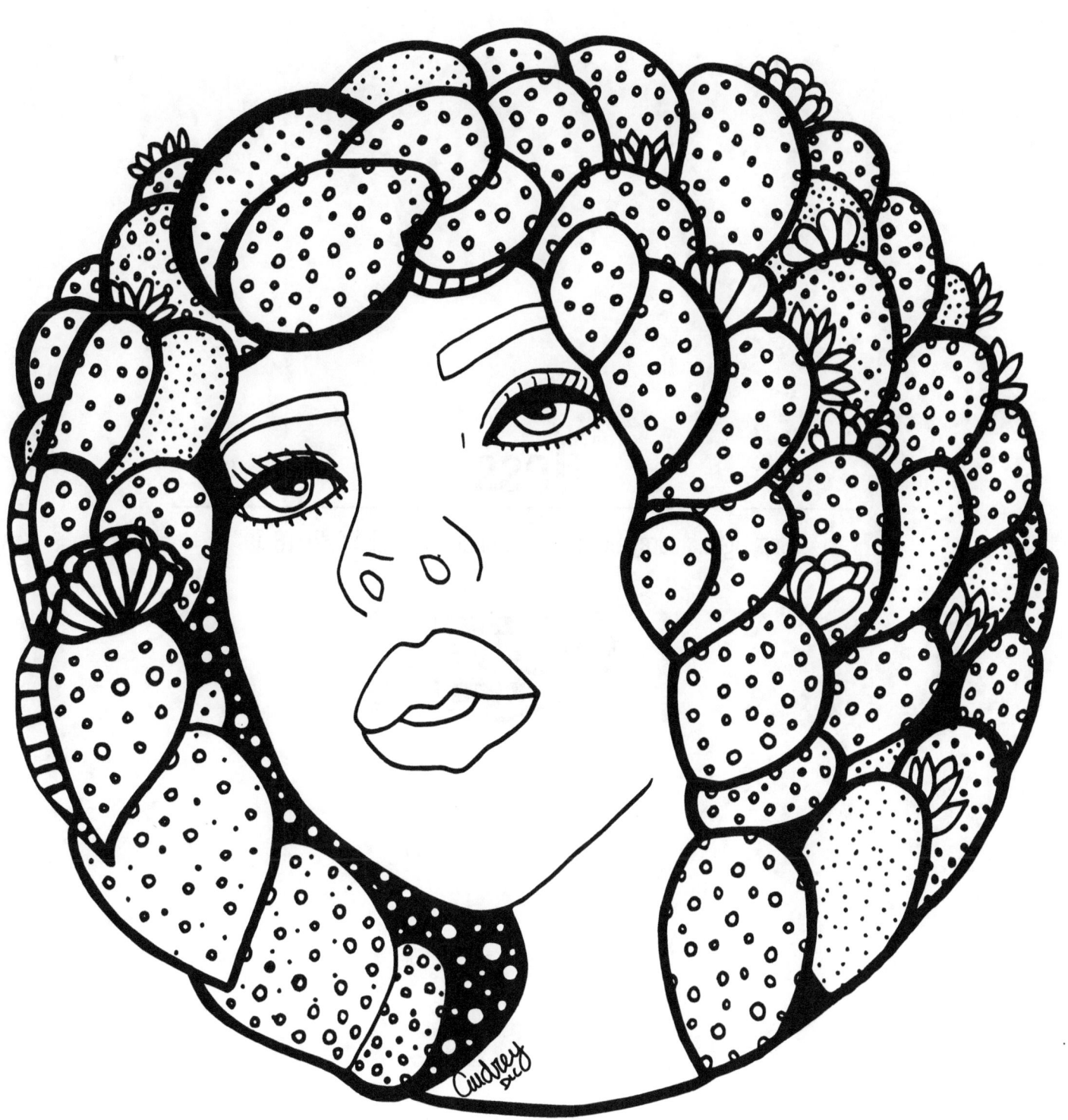

Jess

Copyright. Audrey De La Cruz (Annotated Audrey). 2016 ©

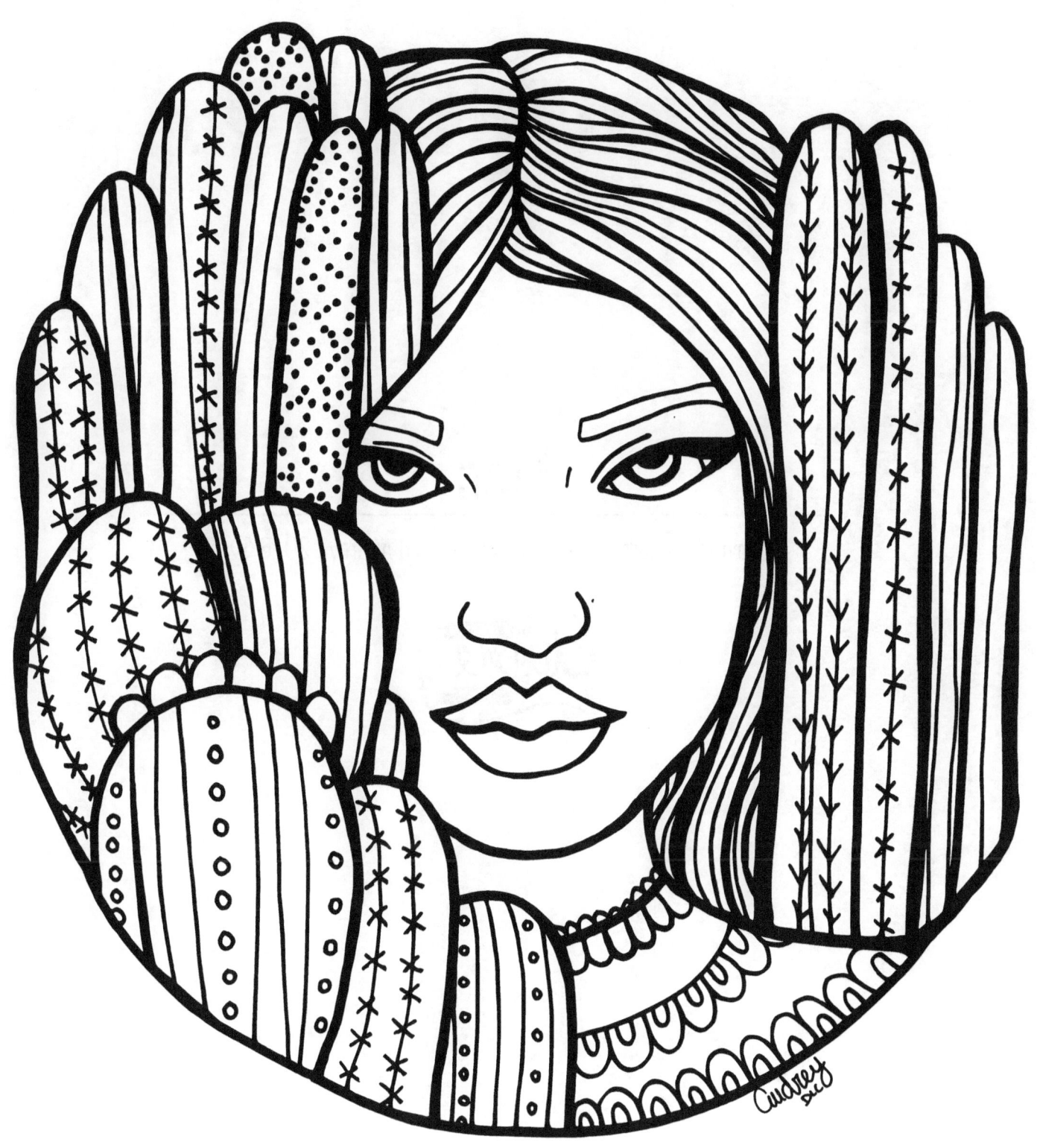

Mac

Copyright. Audrey De La Cruz (Annotated Audrey). 2016 ©

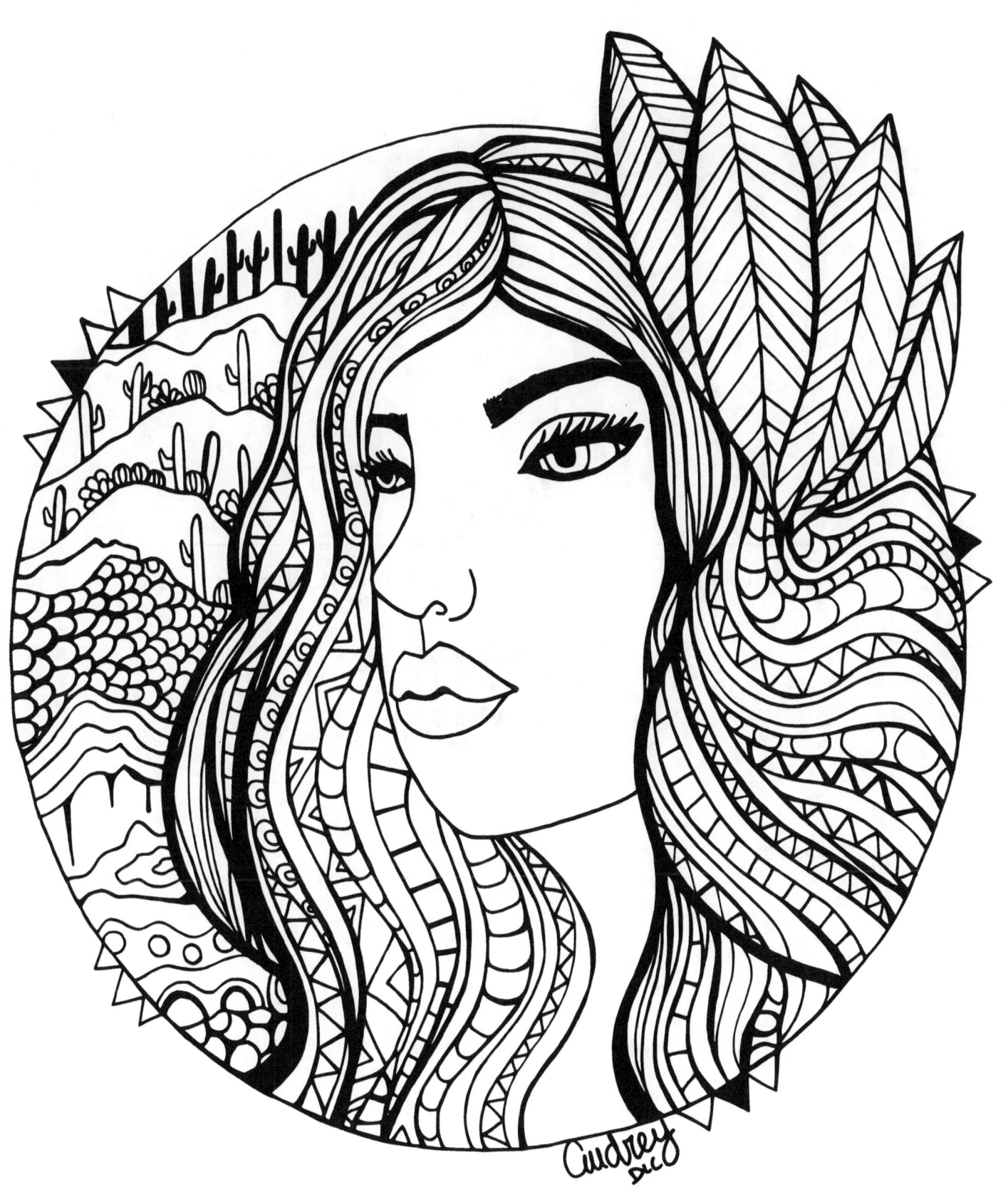

Kelly

Copyright. Audrey De La Cruz (Annotated Audrey). 2016 ©

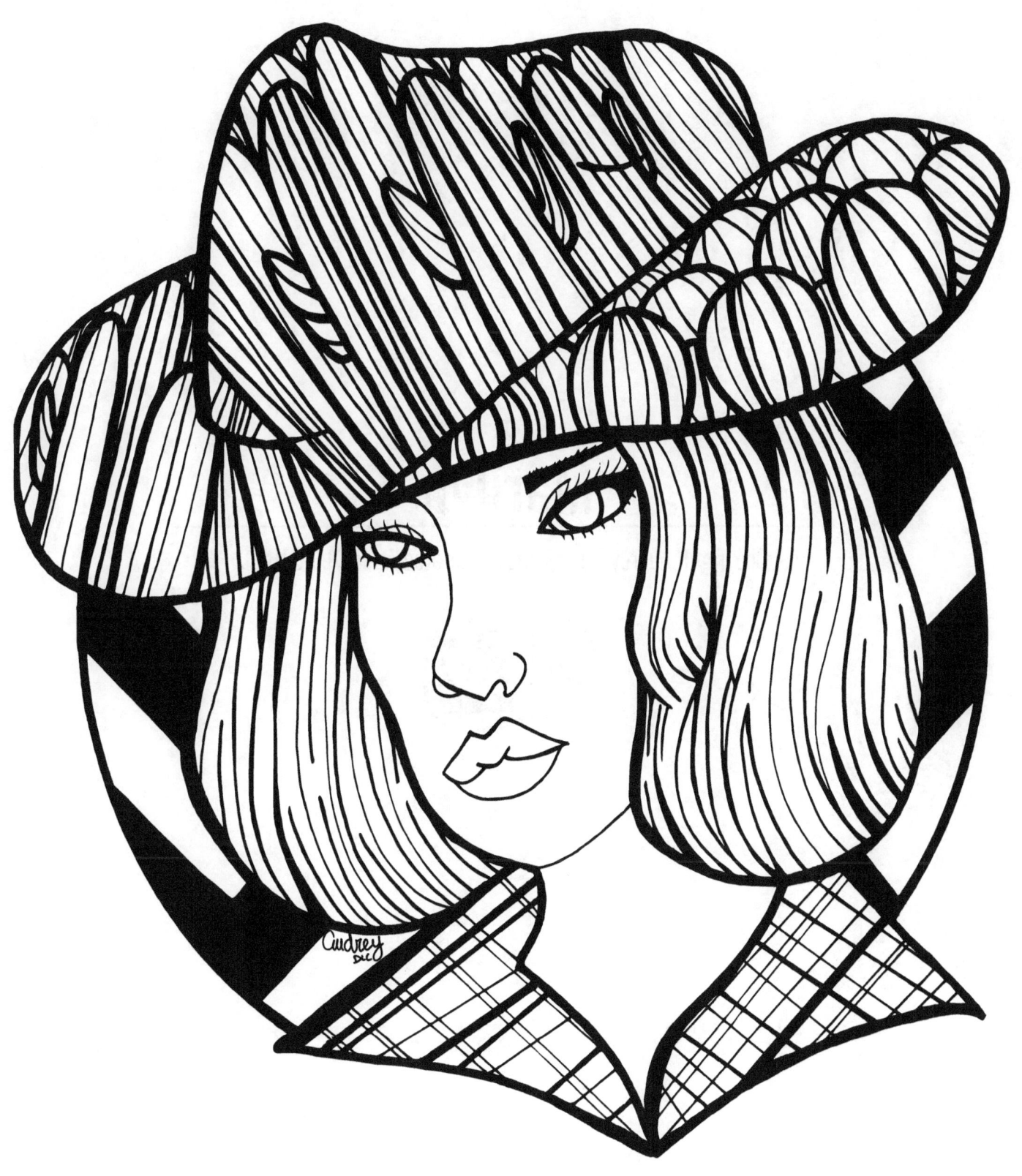

Marilyn

Copyright. Audrey De La Cruz (Annotated Audrey). 2016 ©

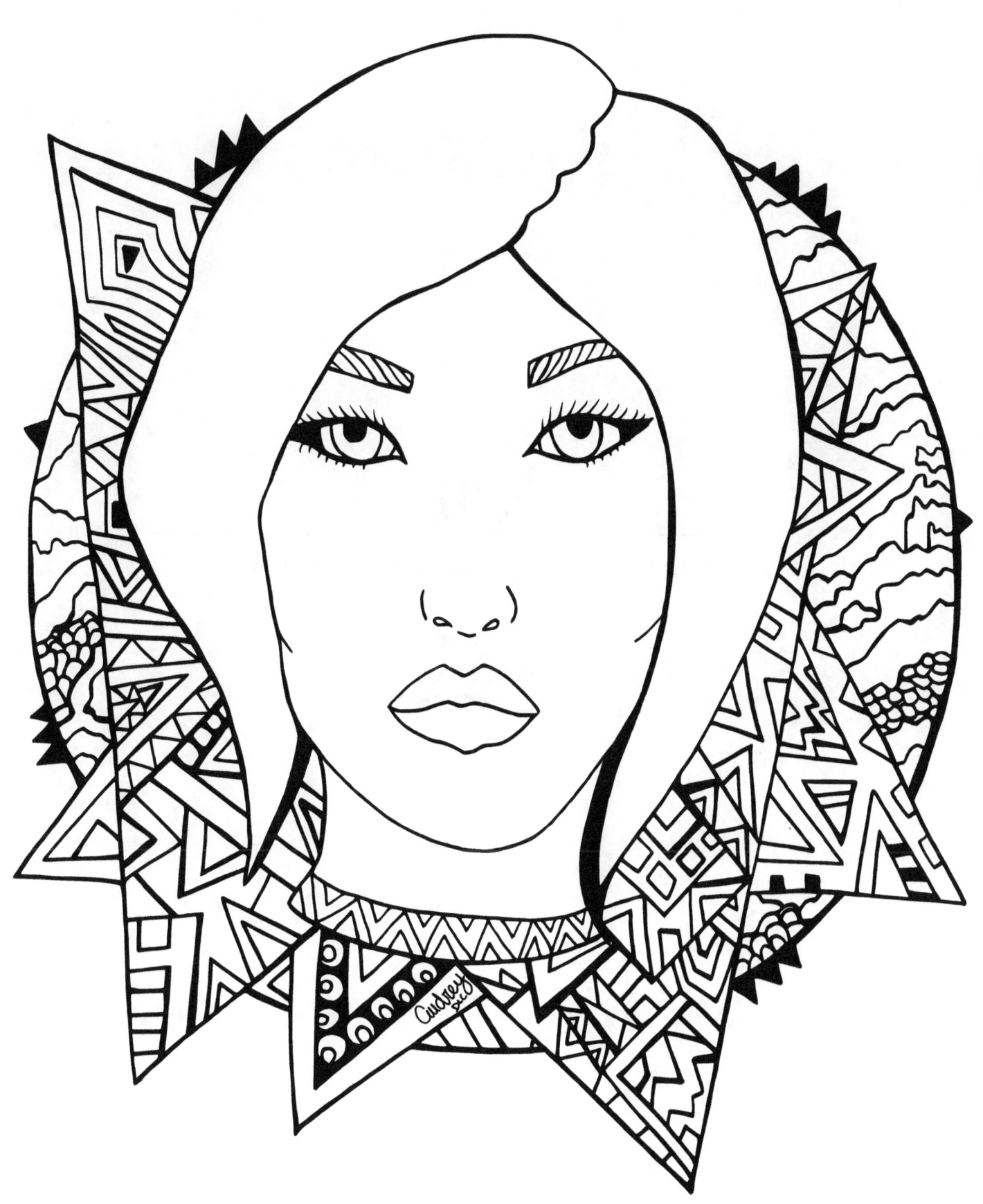

Faith

Copyright. Audrey De La Cruz (Annotated Audrey). 2016 ©

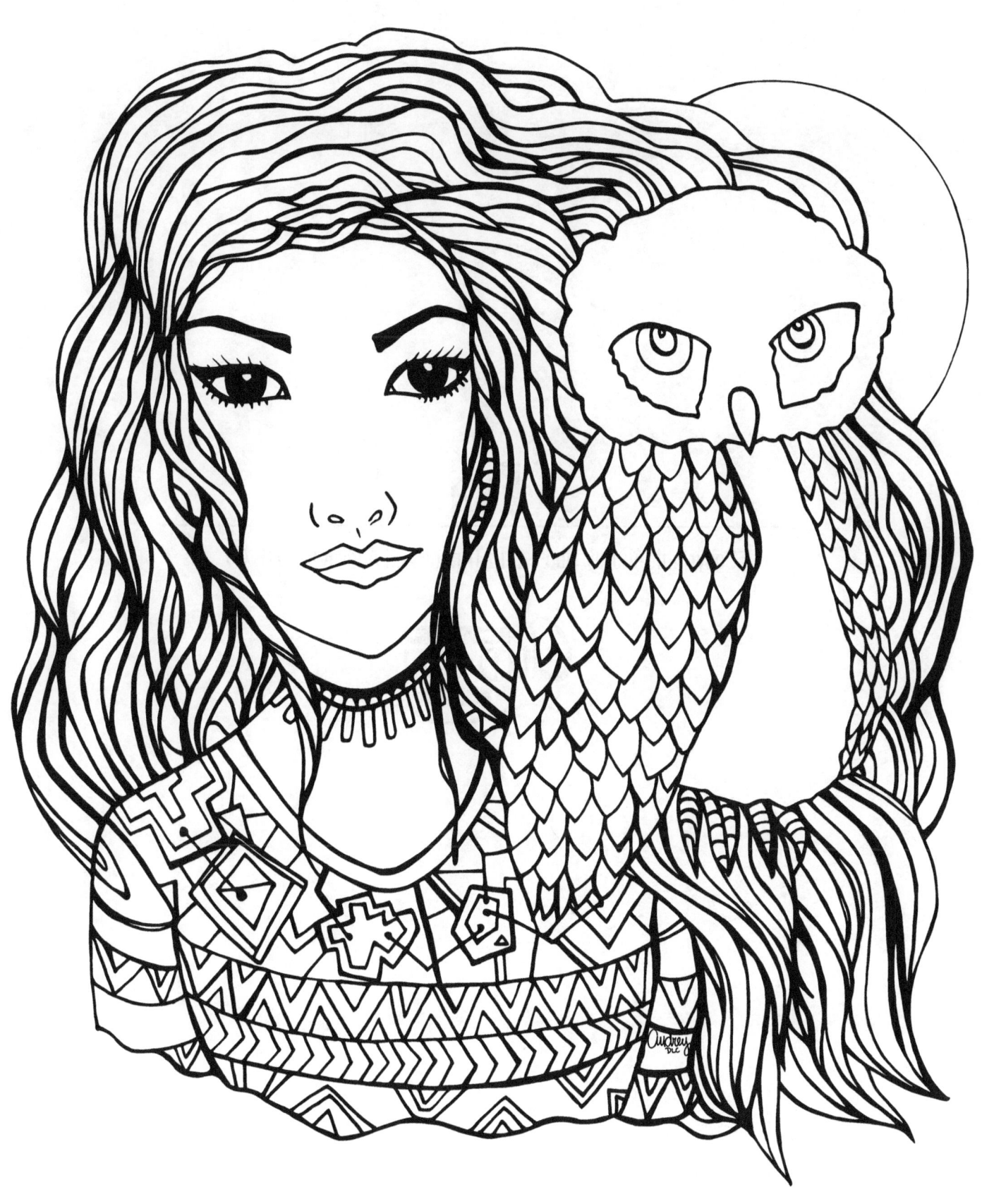

Eva

Copyright. Audrey De La Cruz (Annotated Audrey). 2016 ©

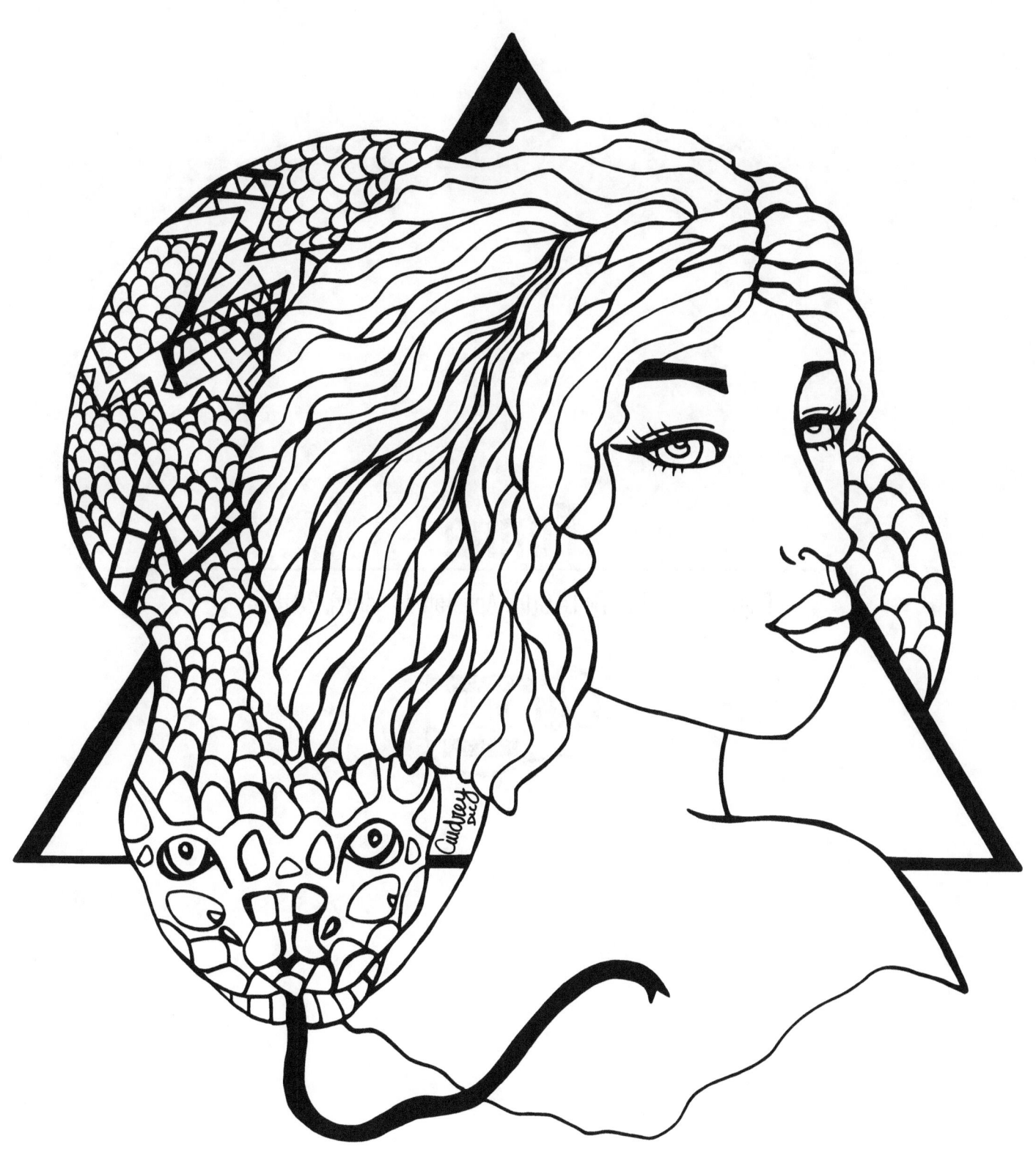

Fenna

Copyright. Audrey De La Cruz (Annotated Audrey). 2016 ©

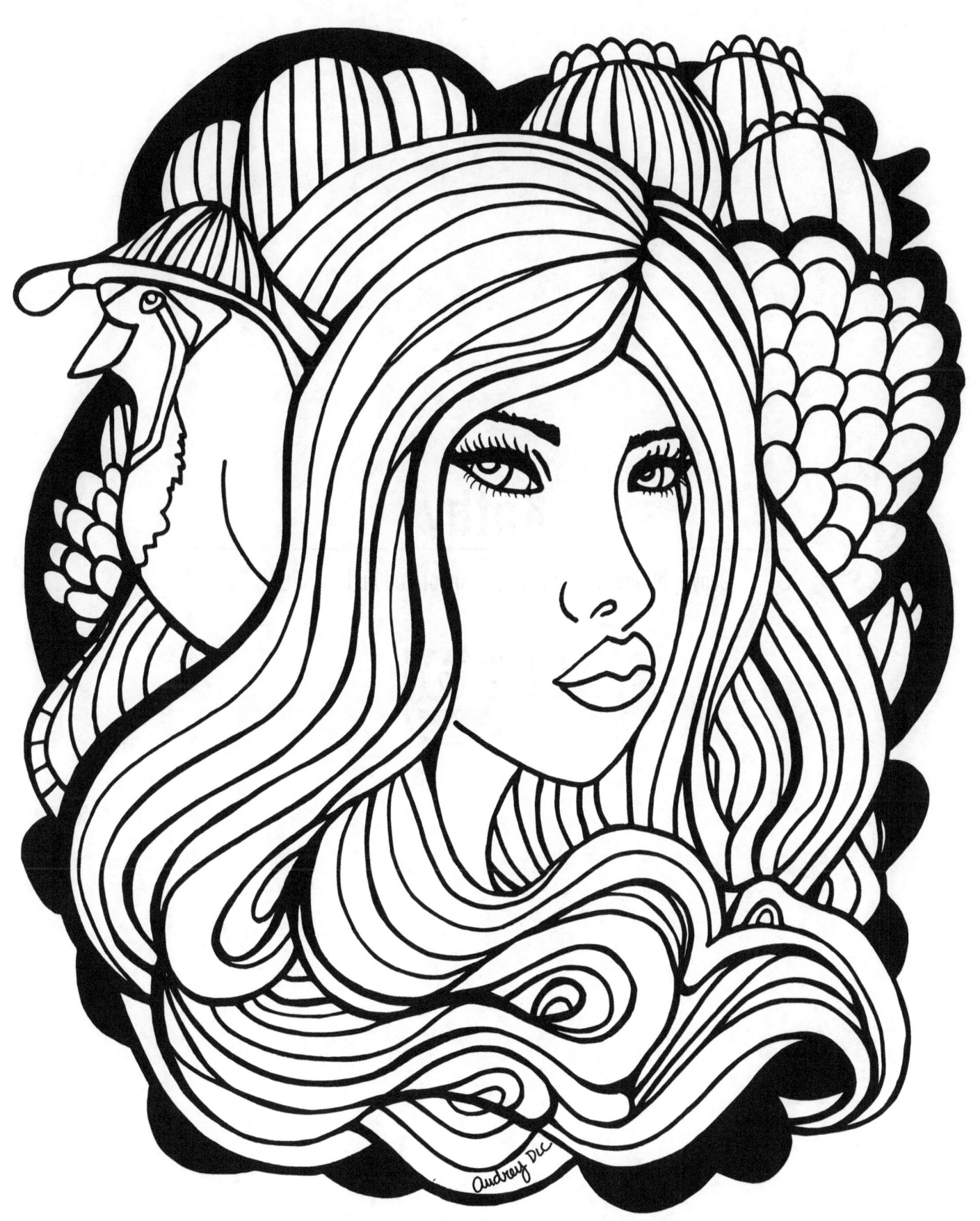

Kathy

Copyright. Audrey De La Cruz (Annotated Audrey). 2016 ©

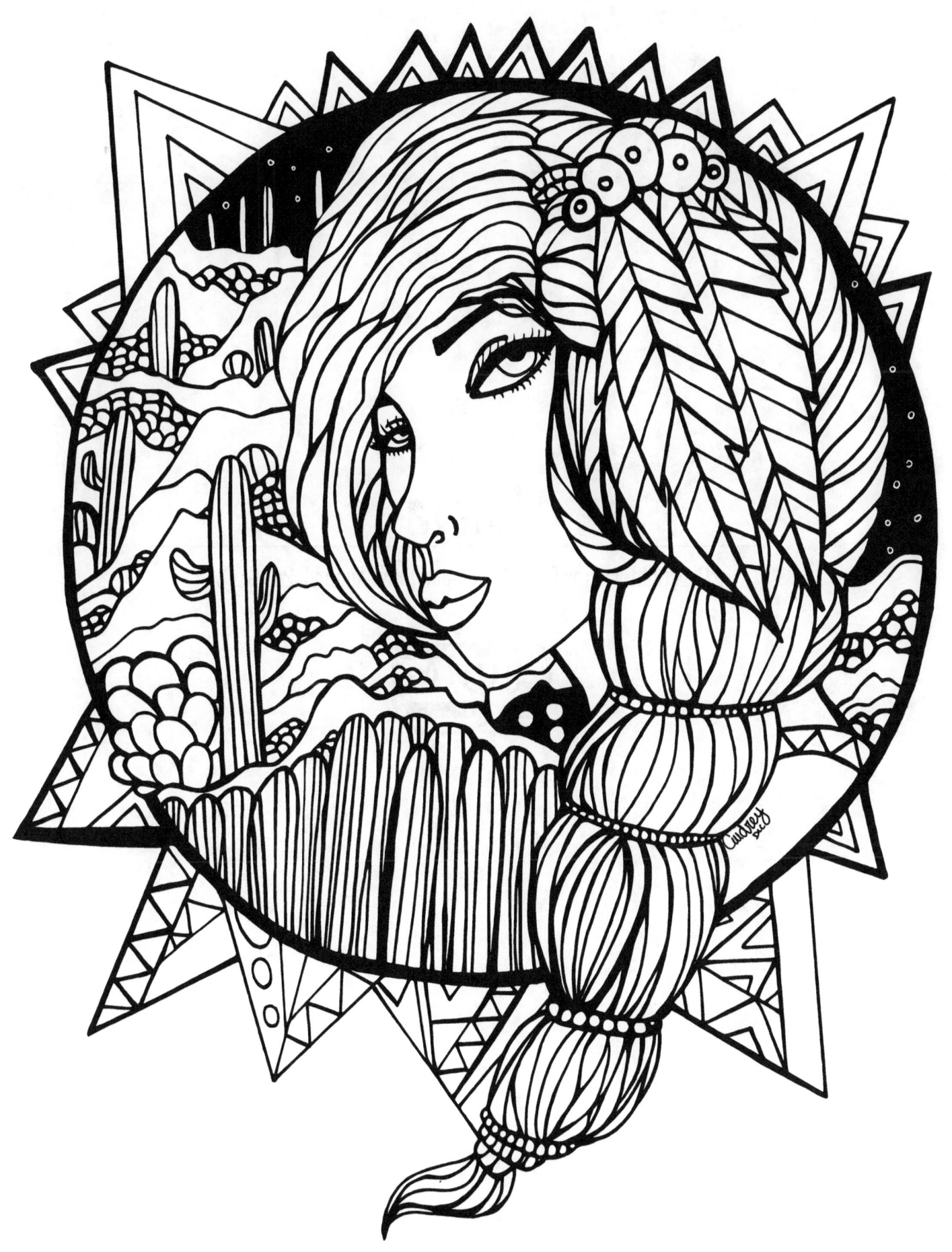

Katya

Copyright. Audrey De La Cruz (Annotated Audrey). 2016 ©

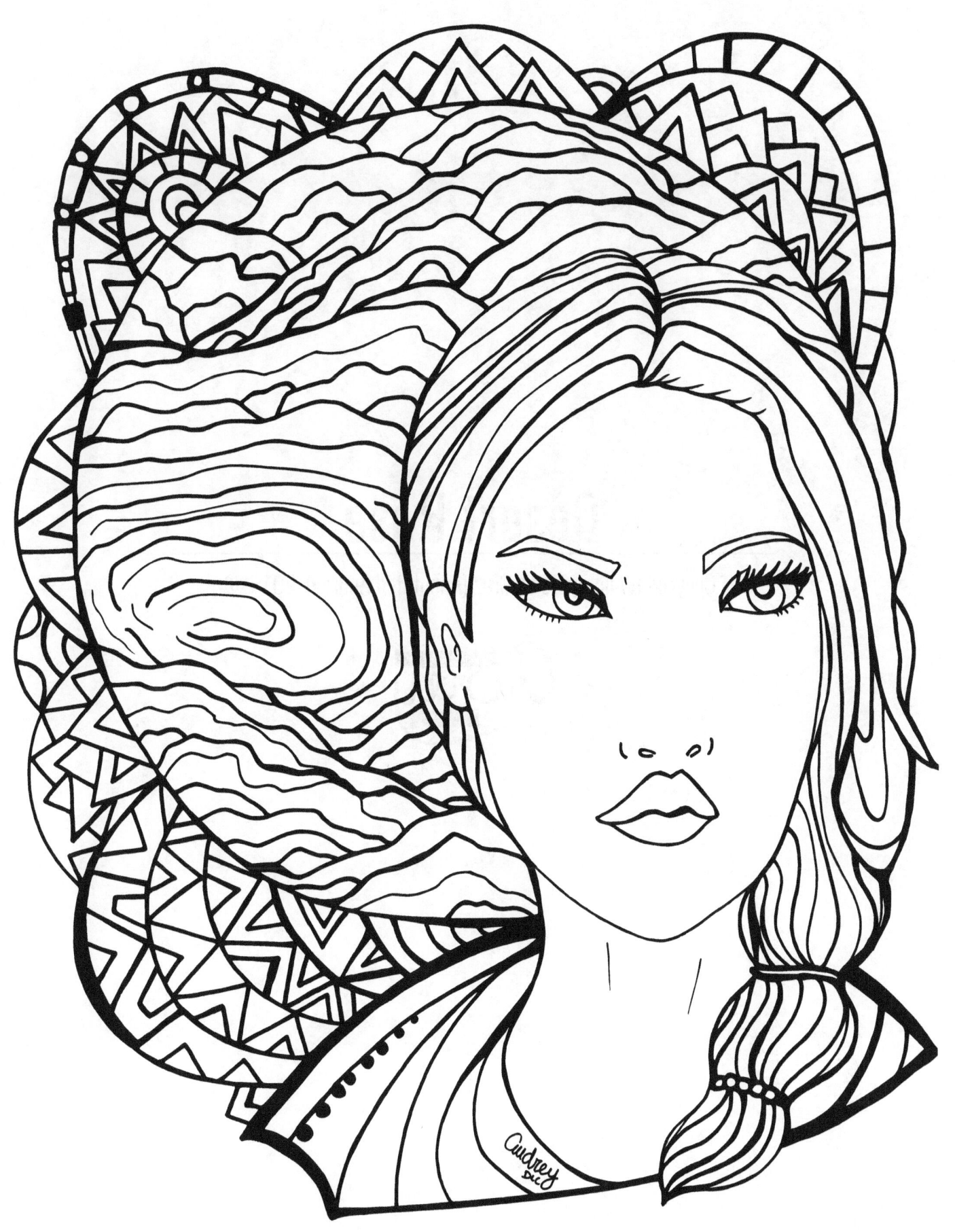

Desert Rose

Copyright. Audrey De La Cruz (Annotated Audrey). 2016 ©

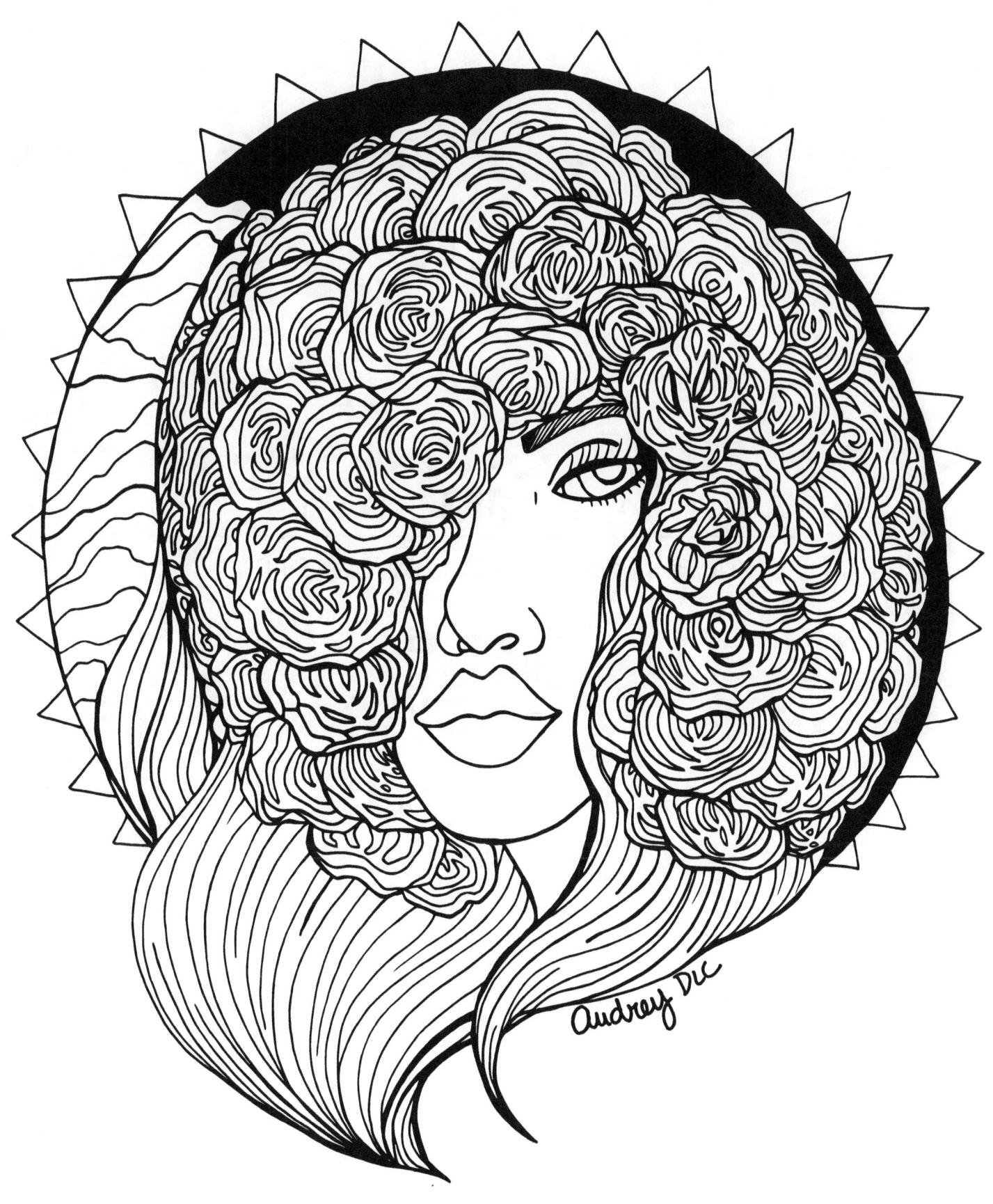

Tara

Copyright. Audrey De La Cruz (Annotated Audrey). 2016 ©

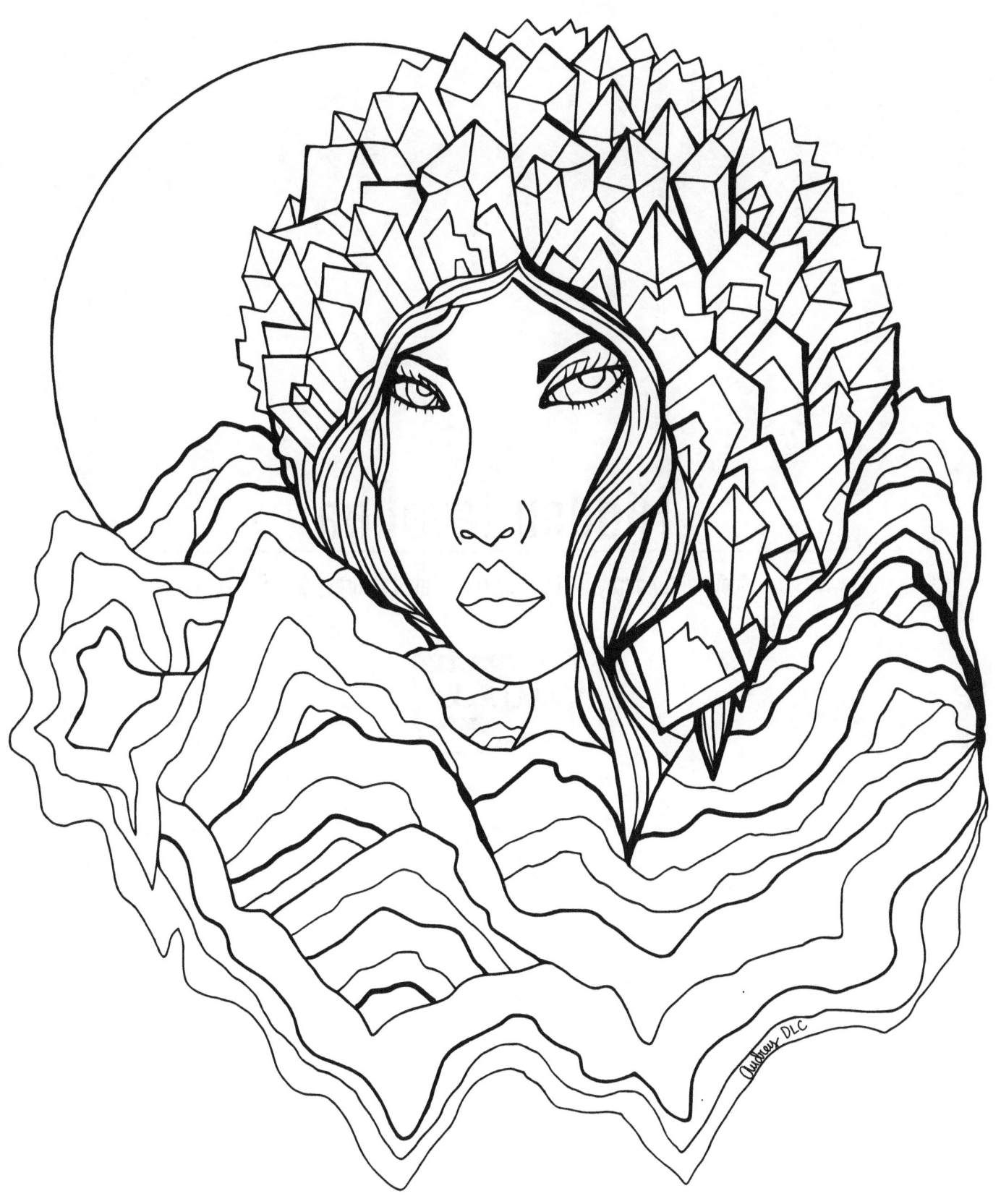

Hidden Javelina

Copyright. Audrey De La Cruz (Annotated Audrey). 2016 ©

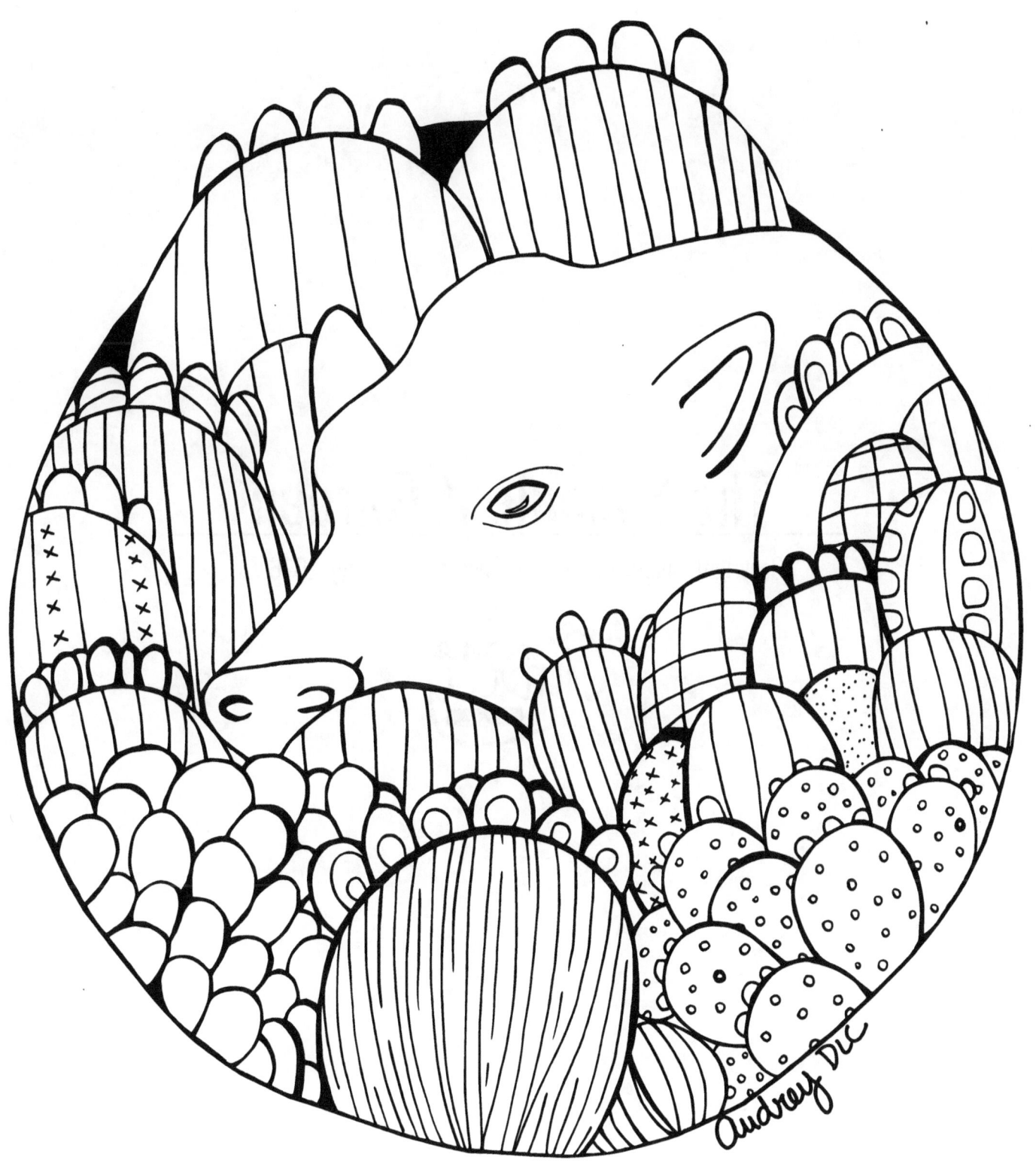

The Succulent Garden

Copyright. Audrey De La Cruz (Annotated Audrey). 2016 ©

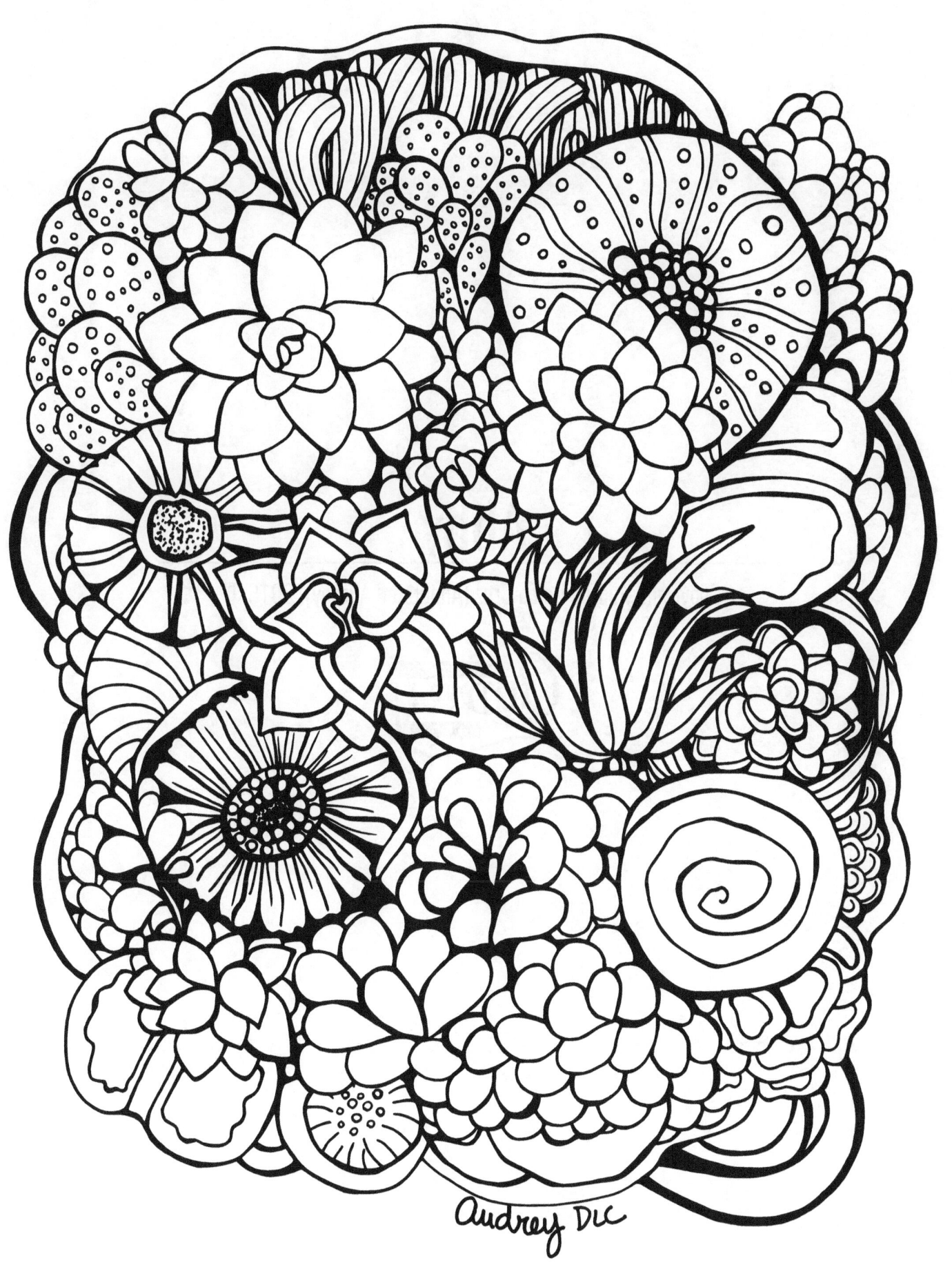

Abby

Copyright. Audrey De La Cruz (Annotated Audrey). 2016 ©

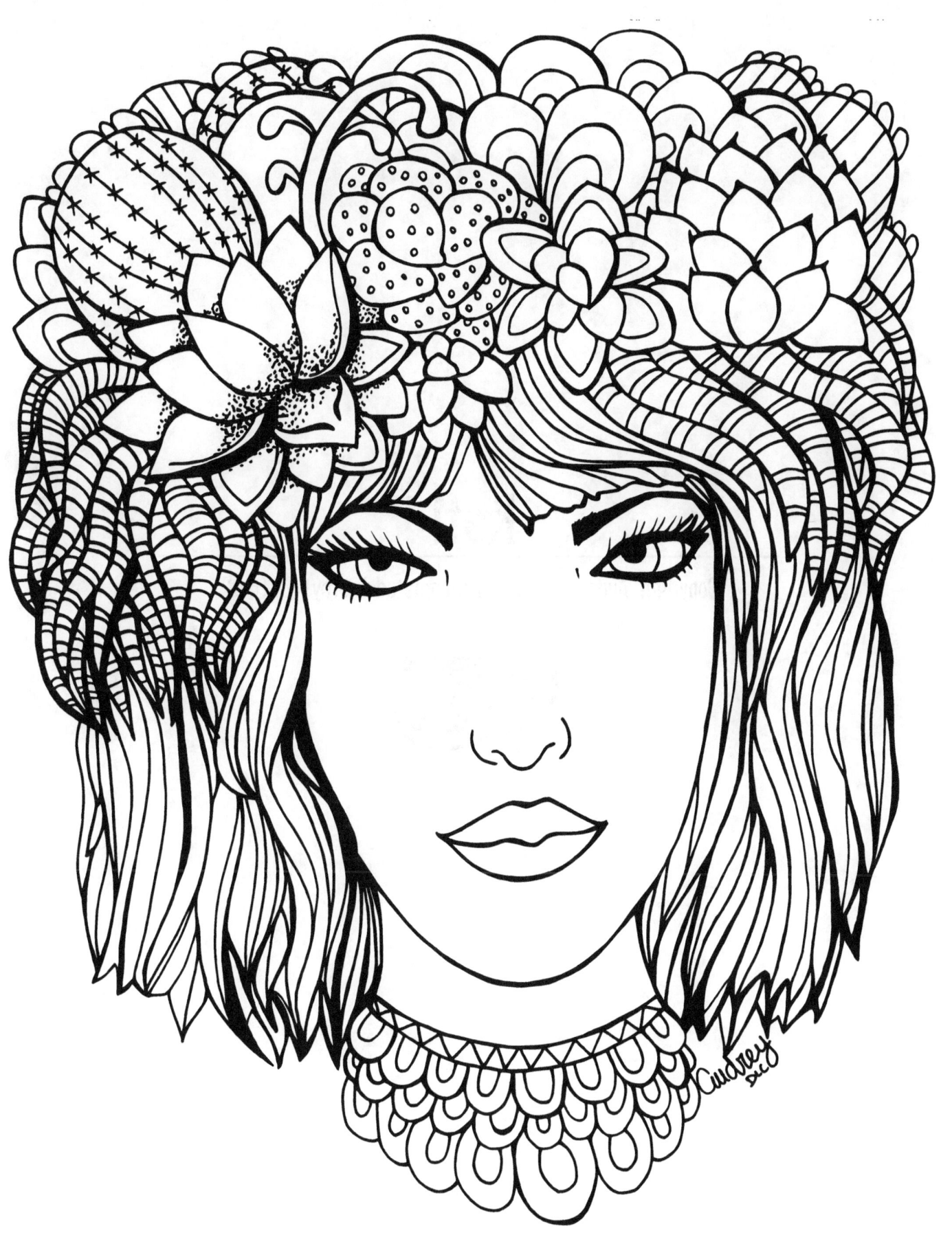

Kati

Copyright. Audrey De La Cruz (Annotated Audrey). 2016 ©

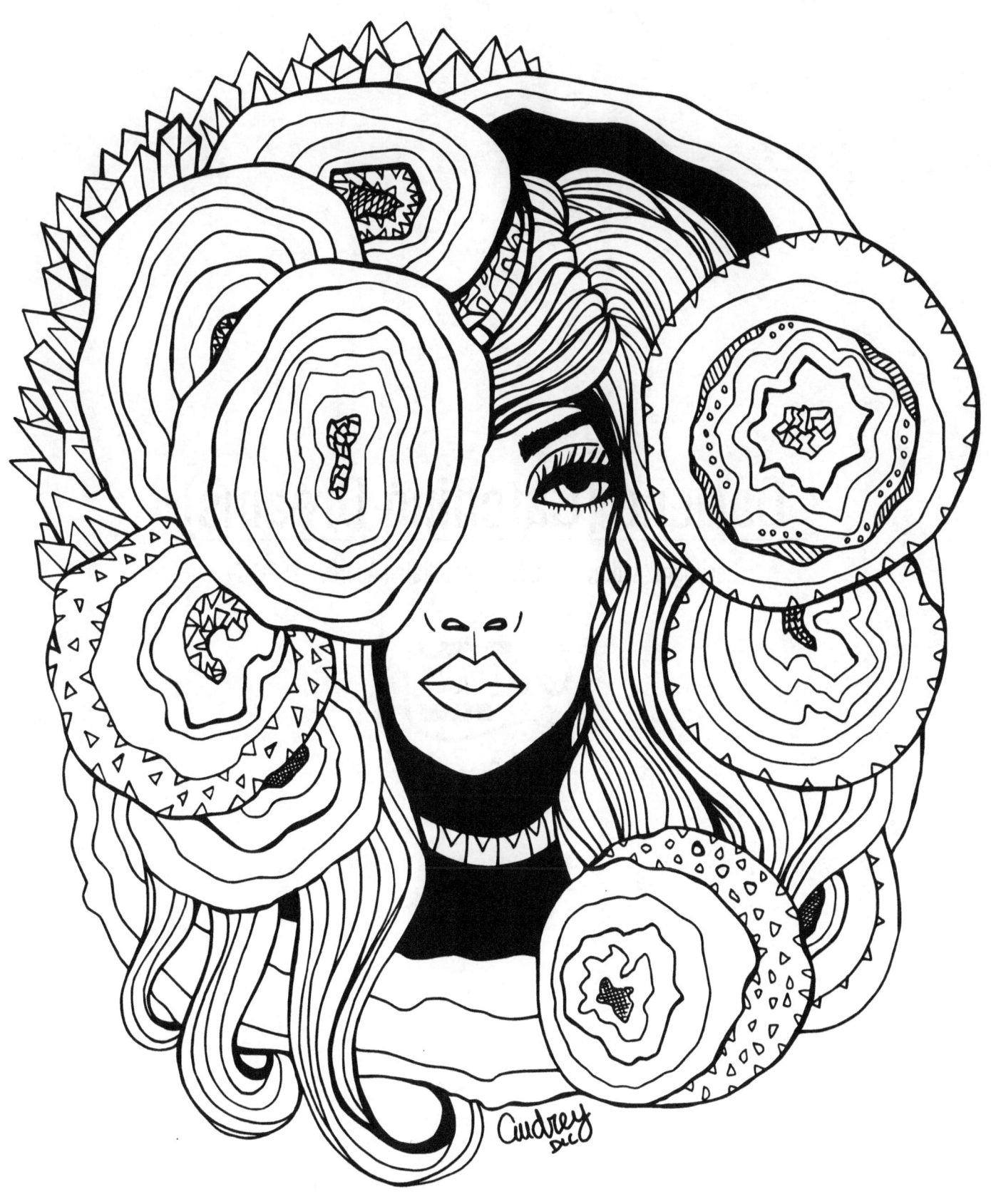

Darlene (Catching Dreams)

Copyright. Audrey De La Cruz (Annotated Audrey). 2016 ©

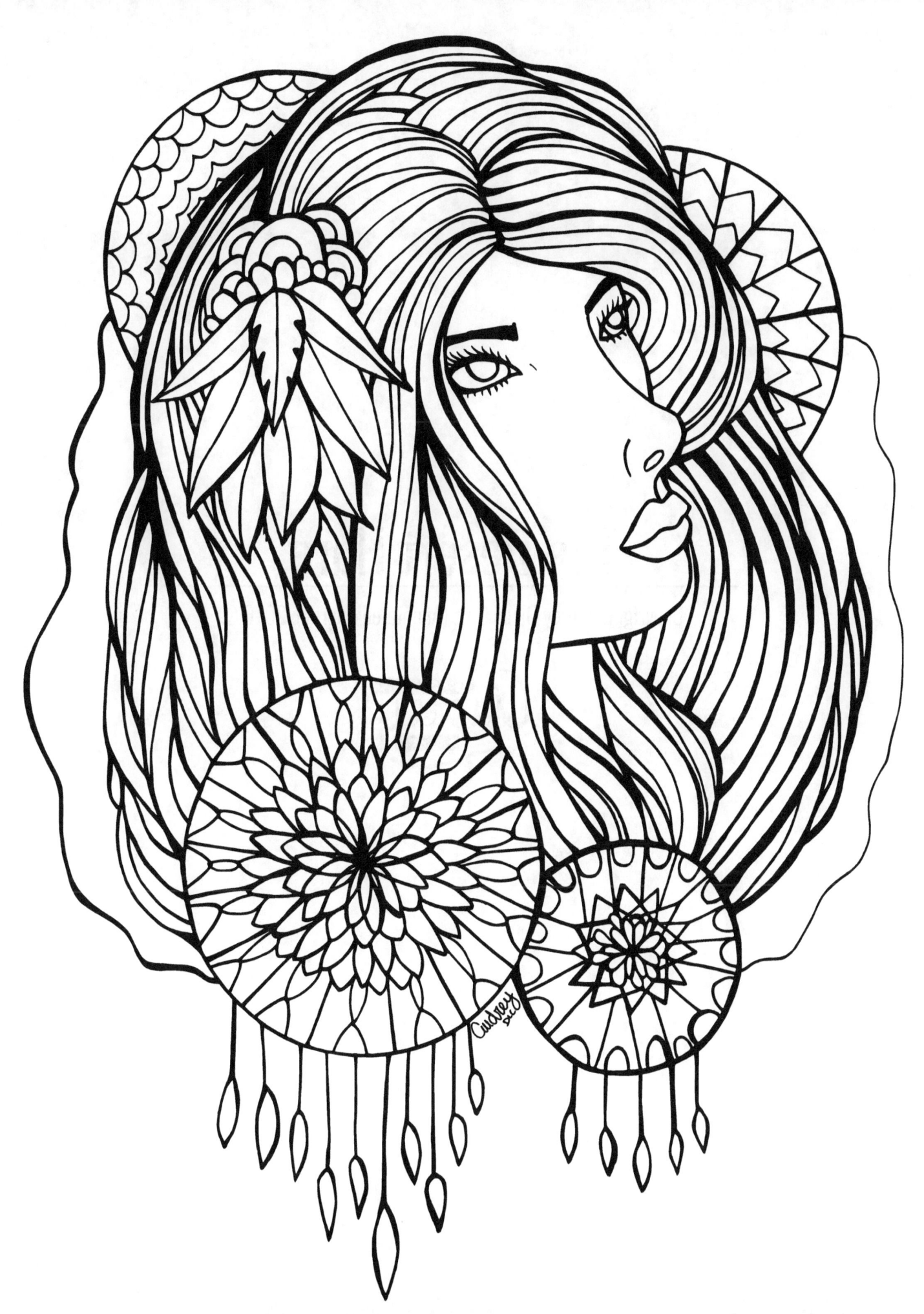

The Desert Hare

Copyright. Audrey De La Cruz (Annotated Audrey). 2016 ©

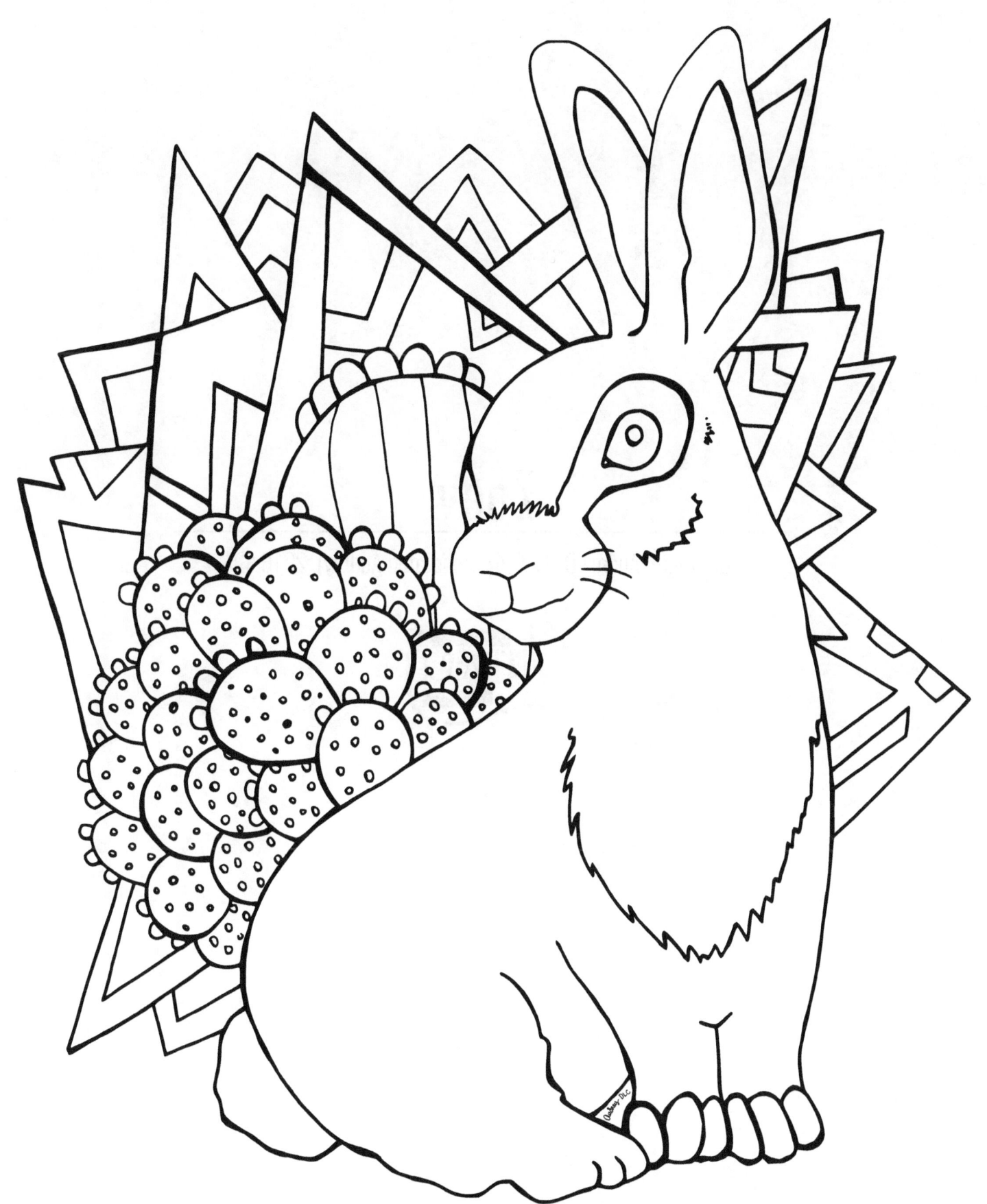

Zoey

Copyright. Audrey De La Cruz (Annotated Audrey). 2016 ©

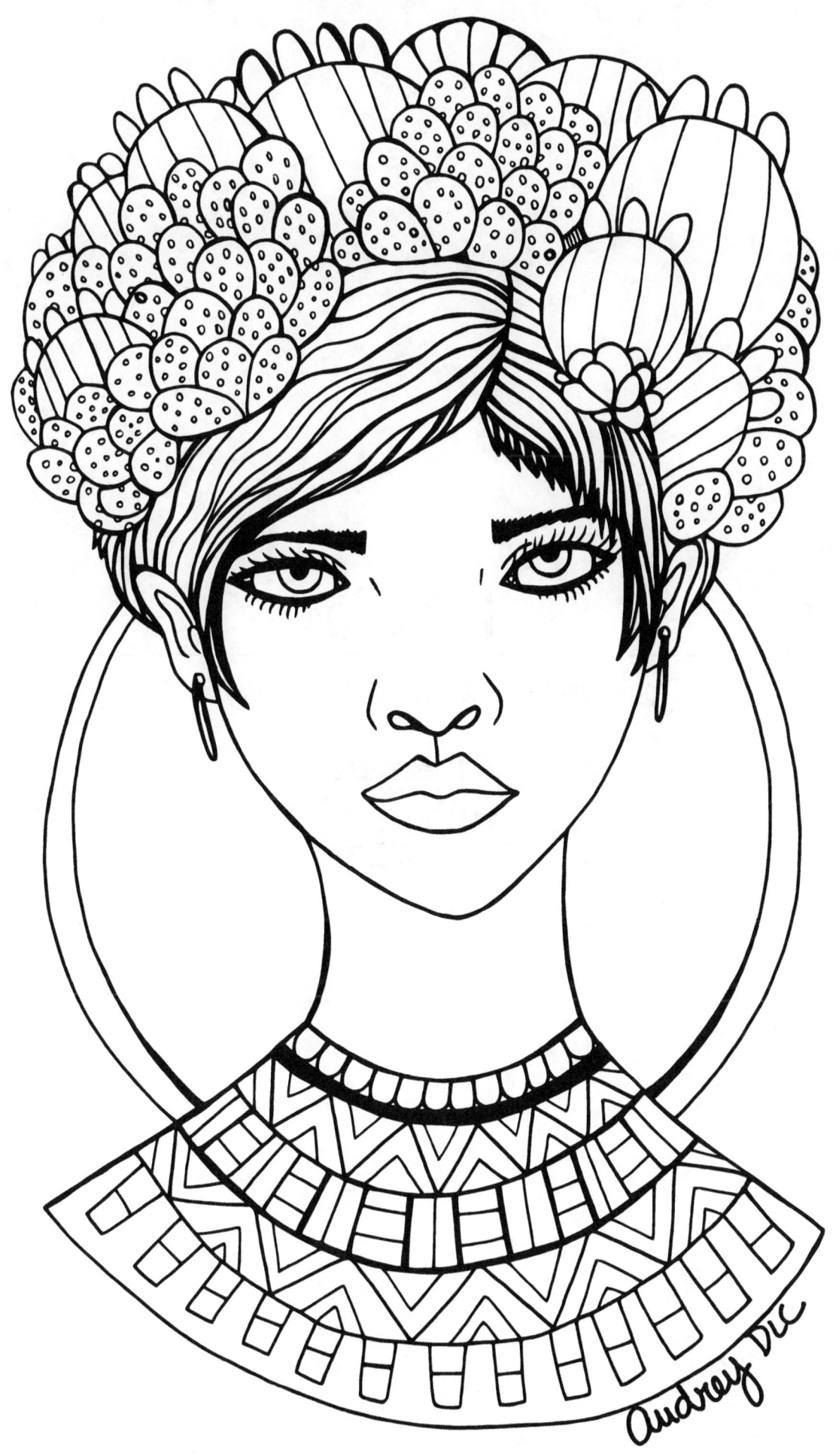

Fabiola

Copyright. Audrey De La Cruz (Annotated Audrey). 2016 ©

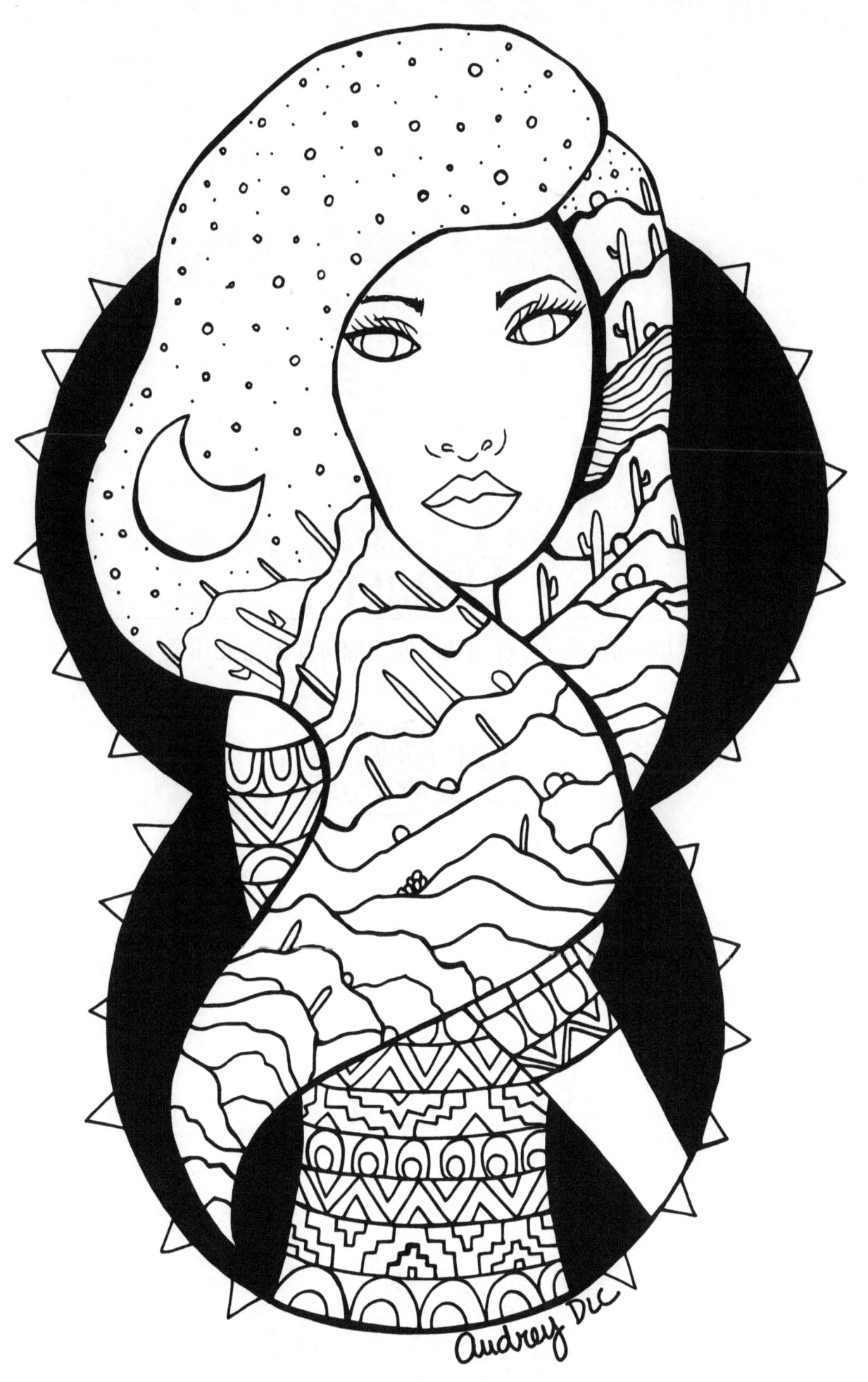

Eleanor

Copyright. Audrey De La Cruz (Annotated Audrey). 2016 ©

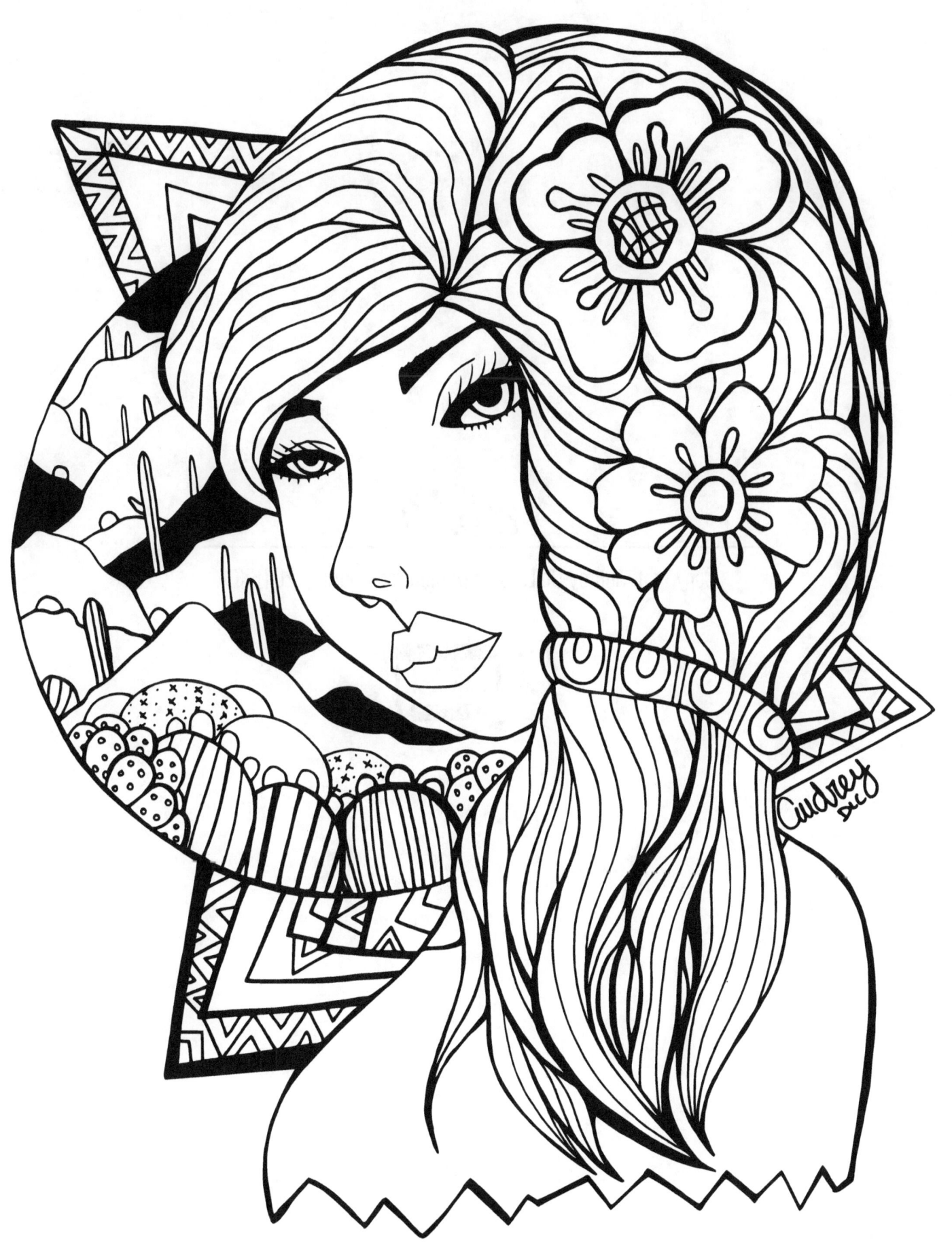

Yaneth

Copyright. Audrey De La Cruz (Annotated Audrey). 2016 ©

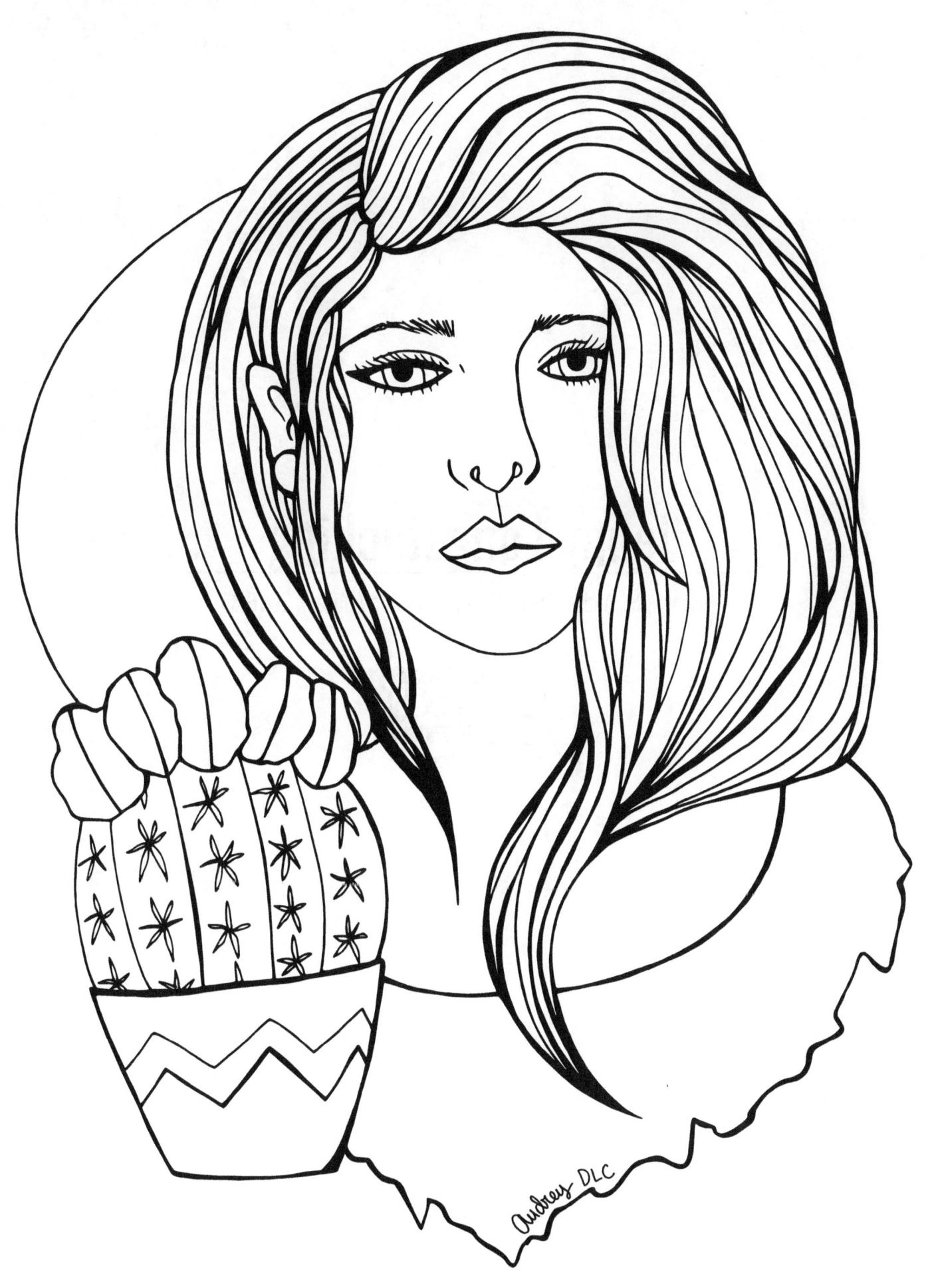

Jenny Longstocking

Copyright. Audrey De La Cruz (Annotated Audrey). 2016 ©

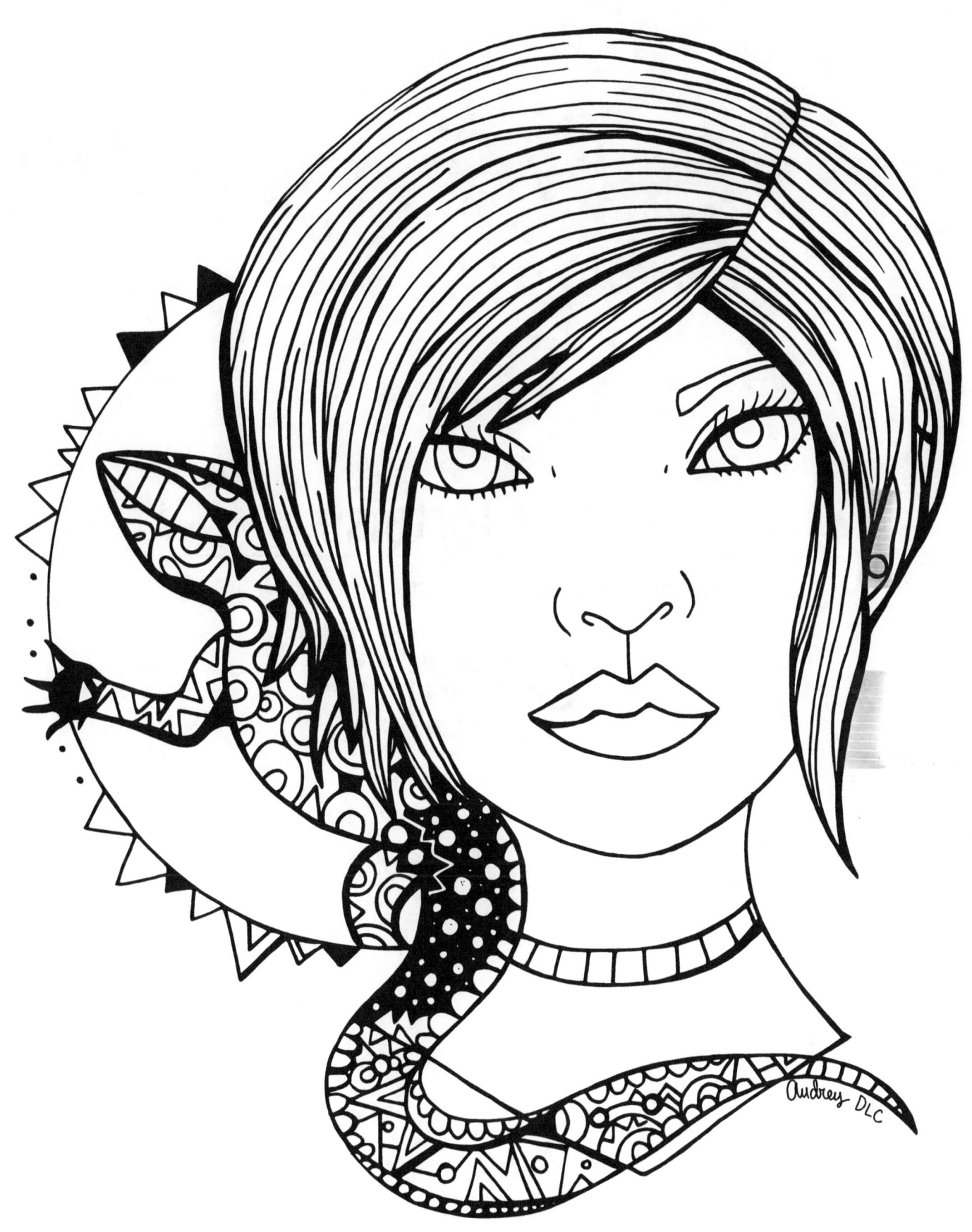

Desert Tortoise

Copyright. Audrey De La Cruz (Annotated Audrey). 2016 ©

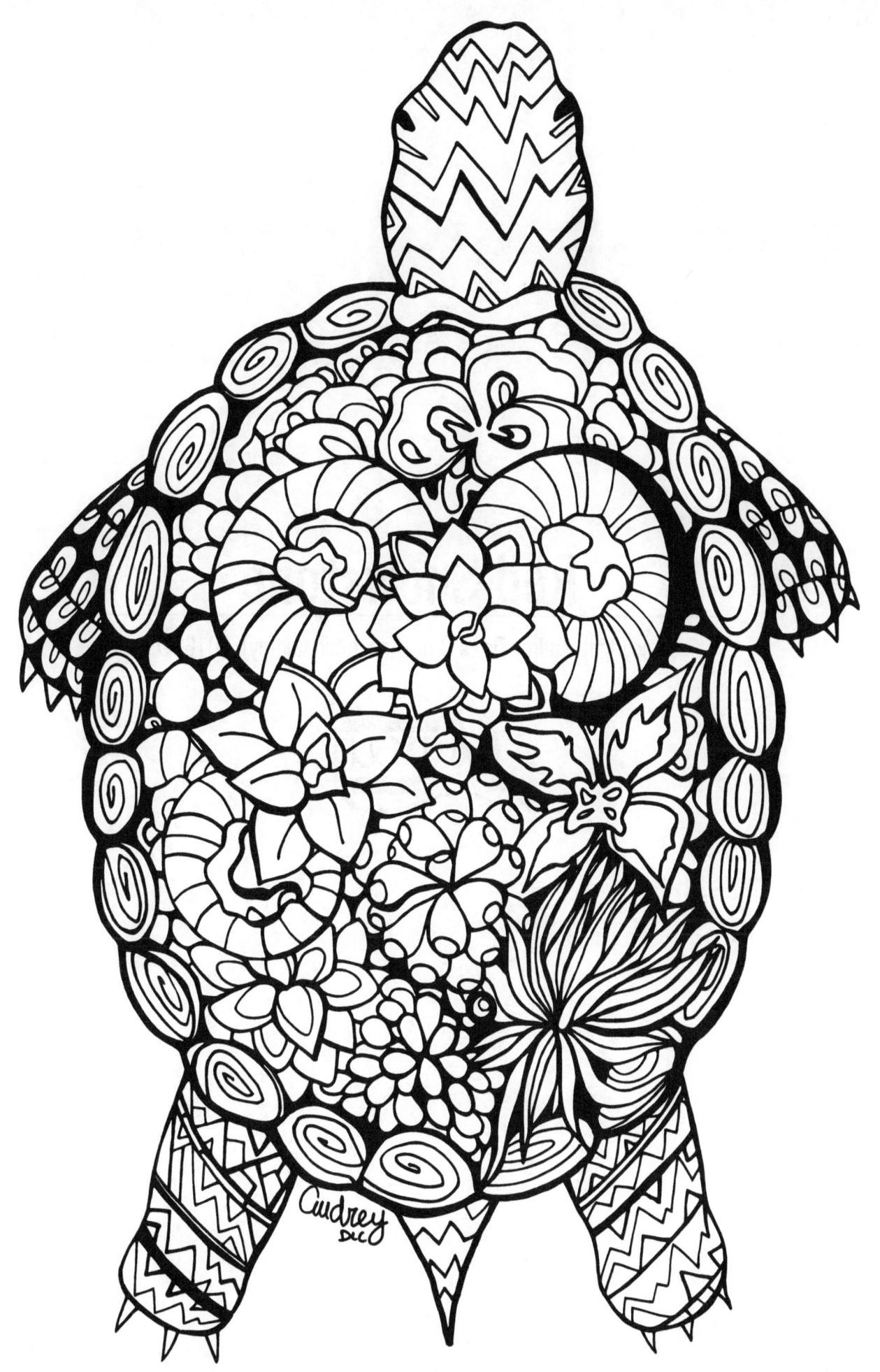

Red Snowstone

Copyright. Audrey De La Cruz (Annotated Audrey). 2016 ©

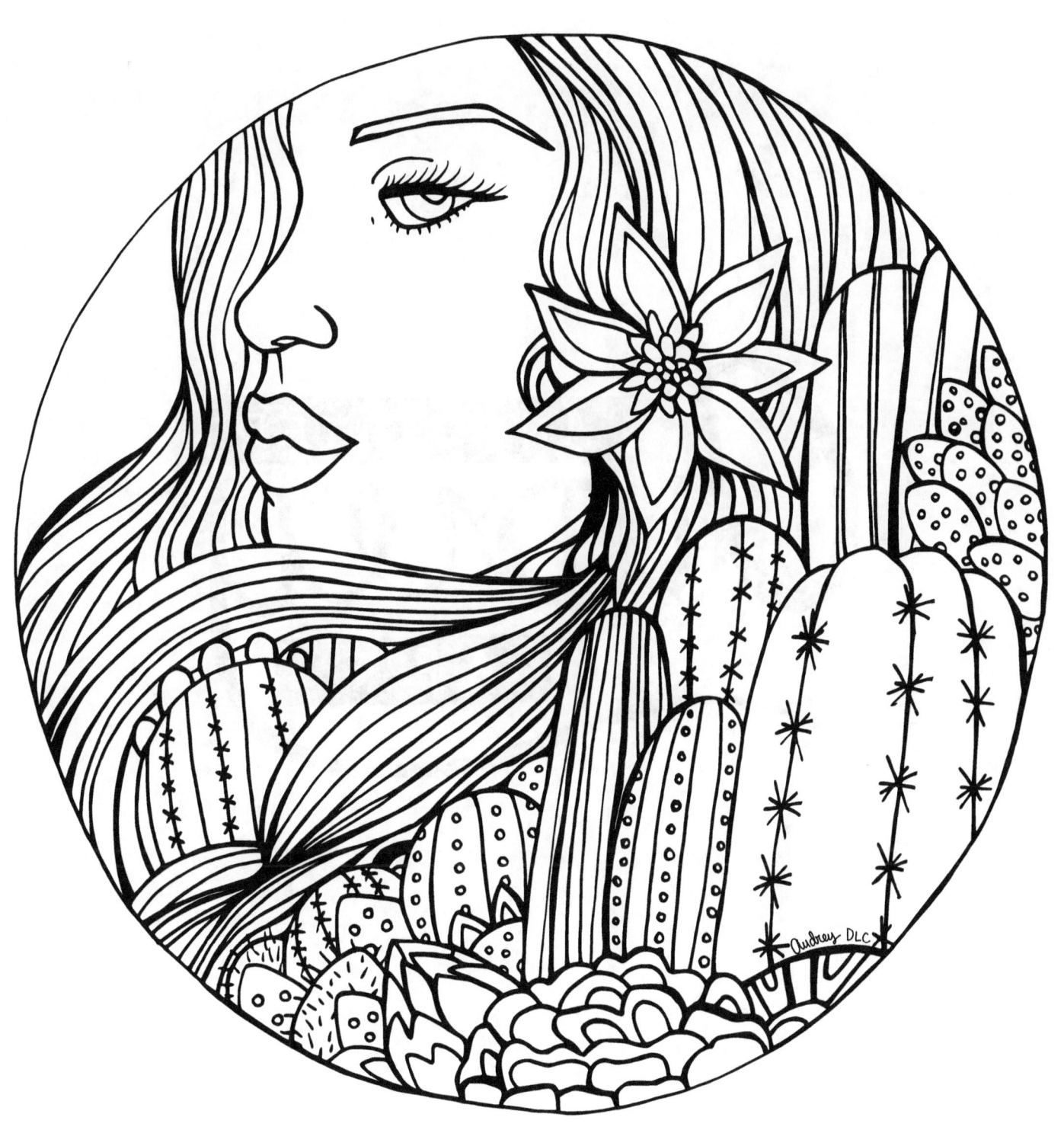

THE FEMININE FLORALS COLORING COLLECTION

By Audrey De La Cruz

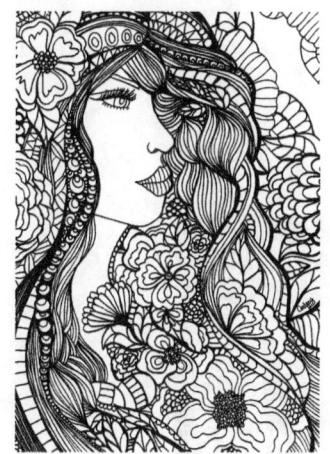

Feminine Florals Coloring Book
ISBN-13: 978-1533449351

Relax and get your creative juices flowing with this beautifully illustrated collection of lovely nature inspired feminine portraits. This book contains 50 unique illustrations by artist, Audrey De La Cruz (Annotated Audrey). Each piece is designed to get you inspired and to ensure hours of stress-free coloring fun.

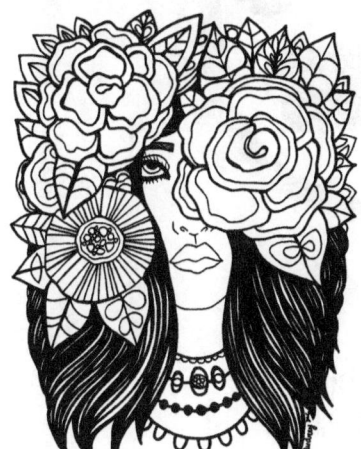

Feminine Florals Purse Edition
ISBN-13: 978-1534716827

A coloring book is always the hottest accessory of the season! This is a mini-version of the Feminine Florals Coloring Book by Audrey De La Cruz. This book contains 30 unique illustrations created by artist, Audrey De La Cruz (Annotated Audrey). Each piece is designed to get you inspired and relaxed no matter where you are!

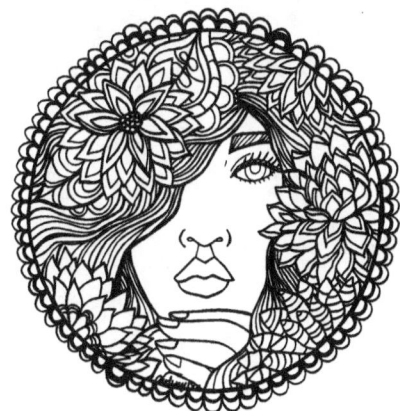

Feminine Florals Coloring and Inspiration Journal
ISBN-13: 978-1534699830

This lovely and inspirational journal features images from the Feminine Florals coloring book by Audrey De La Cruz. Each image is accompanied by an inspirational phrase to boost your positivity and get your creative juices flowing.

Shop the Collection: bit.ly/AudreyDLC

Website	annotatedaudrey.com
Facebook	facebook.com/audreyannotates
Shop	annotatedaudreyart.storenvy.com
Instagram	@annotatedaudrey
Twitter	@annotatedaudrey